# Understanding Perspective

## FORM, DEPTH AND DISTANCE

Dieu,
ombre et
lumière

## SEARCH PRESS

# CONTENTS

December 2010

Giovanni Guglielmo Civardi was born in Milan on 22 July 1947. Following a period working as an illustrator, portraitist and sculptor, he spent many years studying human anatomy for artists. He also teaches courses on drawing the human figure.

*For a long time, dear mother,*
*Your hand I enclosed, warming it, in mine …*
*Grant me, oh Lord,*
*What is now sharp, be easily blunted.*

First published in Great Britain 2012 by Search Press Limited, Wellwood, North Farm Road, Tunbridge Wells, Kent TN2 3DR

Originally published in Italy by Il Castello Collane Tecniche, Milano

Copyright © Il Castello S.r.l., via Milano 73/75, 20010 Cornaredo (MI), 2011 *Prospettiva e struttura: come raffigurare i volumi e le forme*

Translation by Paul Enock at Cicero Translations

Typeset by GreenGate Publishing Services, Tonbridge, Kent

ISBN: 978-1-84448-783-7

The figure drawings reproduced in this book are of consenting models or informed individuals: any resemblance to other people is by chance.

Printed in Malaysia

# INTRODUCTION

*Don't just look, see!*
*The outline is achieved through its interior shapes.*

Different artistic cultures and traditions have devised many and various methods of tackling perspective to overcome the problem of representing spatial depth on a flat surface. The most frequently used – linear perspective – was given its theoretical formulation during the Italian Renaissance. This method cannot be derived simply from looking; instead, it corrects our vision, making it more rational. Before this development and in other, older civilisations such as those of China and Japan, perspective was not given a rigorously 'optical' treatment, but a predominantly hierarchical one. Although understood as thoroughly 'natural' by the cultures that produce them, these forms of perspective have a symbolic function, representing reality in ways not suggested by the natural perspective of the eye. Objects and figures, for example, could take on importance and dimensions unrelated to their actual positions in space, referring more to their thematic importance or social status. Other forms of representation have been developed for other ends: both for practical purposes, as in the case of architectural, engineering and scenographic drawings e.g. axonometric (measured along straight axes) and curvilinear projections (with curved axes), and to meet aesthetic or expressive needs, e.g. reverse perspective as applied in Byzantine art and in the painting of icons.

In recent times, computer-processed projections have greatly simplified many tasks, with suitable software packages to meet every architectural or industrial requirement. For the artist, however, it is still both useful and necessary to possess at least a rudimentary theoretical understanding of which of the various kinds of perspective is best adapted to solving the practical problems of the spatial representation that may be encountered when drawing, for example, a landscape from life, an object or even a human figure. Indeed, perspective is employed in portraying real objects as they are observed (drawing from observation) as well as in the graphic representation of planned or imagined objects and environments. The use of perspective techniques may therefore serve the artist in various ways: in correctly portraying the subject that is being observed from life (an already existing object), in checking for correctness when depicting an object, figure or environment from a photograph and in correctly constructing an object or environment from the imagination (an architectural project, illustration, etc.). In short, when simply drawing any object by eye, artists might find they get better results if they consider (and choose to apply) the basic principles of perspective without thereby sacrificing their expressive and stylistic freedom.

Alongside the interpretation of perspective, it is important that the artist also investigates the structure of the subject. An object's structure indicates the way in which its parts relate to the whole. For this reason, a structural drawing also tries to bring out traces of relevant features, such as its essential planes, the axes of its sections, etc, which remain hidden from view but may be guessed at, as if in see-through projection. This kind of treatment completes the representation of perspective by building up and evaluating the individual proportions of each part and the overall arrangement.

Investigation of both perspective and structure will provide guidelines for drawing with confidence and fluency. A freehand sketch from life of any subject, be it man-made or organic, simple or complex, will be better understood, expressed or corrected using the rules that the theory of perspective has uncovered and formulated. The idea is certainly not to regiment artistic expression or to put it in a cage, but rather to render its outcomes and ideas more plausible and effective.

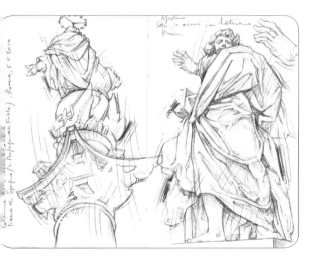

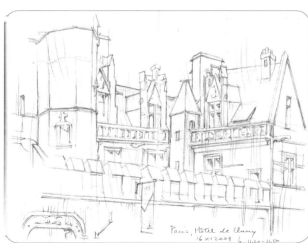

Sketchbook pages in pencil on paper, 9 × 14cm (3½ × 5½in)

3

# GETTING STARTED

## TOOLS

When you are drawing from life, the subject itself will often suggest the most suitable tools and the right methods to tackle its perspective. In the photograph below I have assembled some tools and materials which you may find useful to have at hand: sheets of paper, sketchpad, tracing paper, bulldog clip, stencil for ellipses, a pair of compasses, ruler, protractor, fine graphite pencil (mechanical pencil),

slide mount (framing device) and a set square (90° and 45°). Sometimes, other tools suggest themselves, and even everyday objects may be brought into play effectively, such as an old envelope or an out-of-date credit card: these perform the function of evaluating and drawing angles and straight lines surprisingly well.

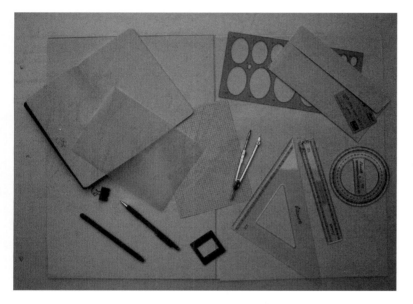

### EXERCISES FOR DRAWING SIMPLE LINES USING TOOLS OR WORKING FREEHAND

It is important to become proficient at assessing the orientation and length of lines and the sharpness of angles by eye as well as in drawing geometrical layouts with precision and certainty so that you can avoid having second thoughts or making blunders (see page 35 on this as well). For example, even if you are drawing freehand, a straight line still has to be a straight line and angles, circles or ellipses have to correspond to these particular geometrical

patterns, or at least suggest their properties in a sound and convincing way. One truly valuable method for training hand and eye coordination is by moving gradually from drawing lines with the aid of drawing instruments such as a pair of compasses, rulers, set squares, etc. to executing the same lines freehand. This can be done in stages, moving from freehand copying of lines made using mechanical aids to free and immediate execution.

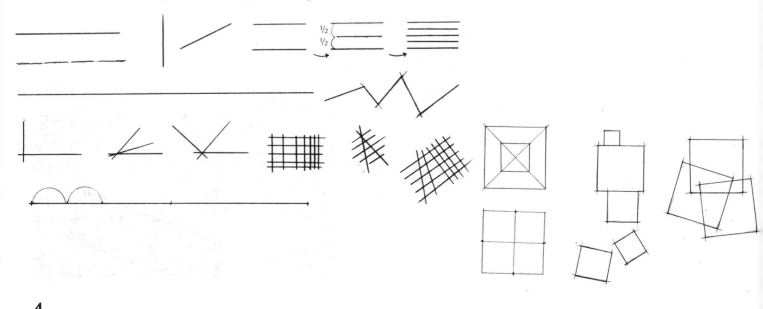

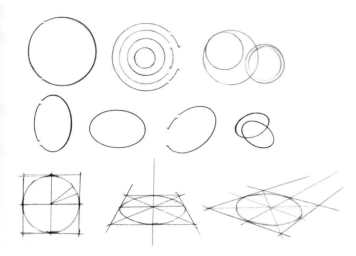

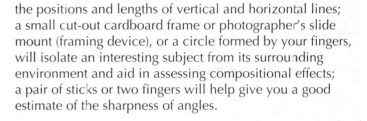

## PRACTICAL METHODS FOR ASSESSING ANGLES AND EDGES BY EYE

It is not always easy to judge by eye – especially with precision – the directions taken by an object's principal lines and the angles that are formed between them. This is especially demanding when you are trying to depict an architectural construct on, a building's interior or any other complex object while working from life. For this reason, artists have made use of some simple and readily available tools. For example, a pencil can be used to gauge the positions and lengths of vertical and horizontal lines; a small cut-out cardboard frame or photographer's slide mount (framing device), or a circle formed by your fingers, will isolate an interesting subject from its surrounding environment and aid in assessing compositional effects; a pair of sticks or two fingers will help give you a good estimate of the sharpness of angles.

## THE MAIN TYPES OF LINEAR PERSPECTIVE

The following diagrams show the most common types of perspective used in artistic representation. When observing an object from life, or when imagining an object, it is worthwhile considering straight away what would be the most effective perspective scheme to use for its optimal expression.

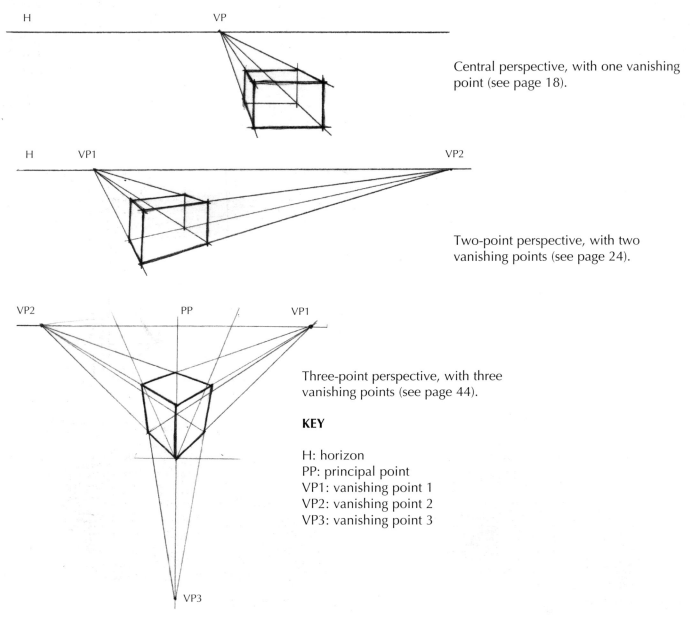

Central perspective, with one vanishing point (see page 18).

Two-point perspective, with two vanishing points (see page 24).

Three-point perspective, with three vanishing points (see page 44).

### KEY

H: horizon
PP: principal point
VP1: vanishing point 1
VP2: vanishing point 2
VP3: vanishing point 3

## POSITIONING THE OBJECT ON THE PAPER

When depicting an object according to the principles of linear perspective, you will need to refer to the points at which lines converge on the horizon (the vanishing points). These points are nearly always positioned off your drawing paper, perhaps at some distance from the page's margins. There are simple tricks for overcoming this difficulty (see page 31). In order to estimate the location of these points and where to position the horizon line, it is a good idea to measure the angle formed between the object's main lines (or the main lines of a geometrically simplified version of the object) and project them on to the horizon line.

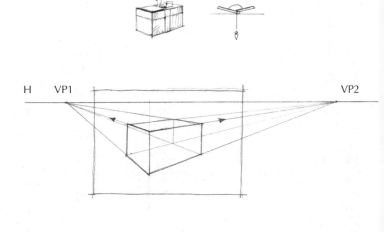

## USING PHOTOGRAPHS AND THE PROBLEMS OF DISTORTION

Linear perspective applies a monocular (single lens) principle to representing space on a flat surface, but our vision is binocular. Our field of vision, or 'visual cone' has a generously angled apex of approximately 45° and this means everything we see is viewed in this arc. Objects within this area are not distorted and are seen in their true spatial proportions according to our natural perspective. If the angle of the visual cone is less than 45°, the image will be perceived as shrunk and flattened. If the angle is more than 45°, the image will appear magnified and its proportions

contorted to some extent. When using a camera without specific equipment such as a special lens or other optical compensator, the distortions in a photograph may not jump out because the tonal blending softens their appearance. Instead, they will show up more obviously in a drawing that has used this photograph as its only source of information. It is also worth bearing in mind that these dimension-altering effects show up more in photos of buildings or artificial objects, but appear subtler in photos of natural, organic forms such as faces, figures, flowers or landscapes.

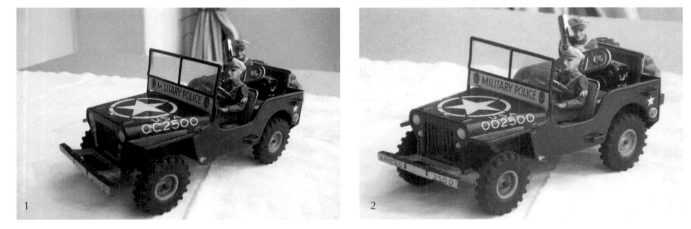

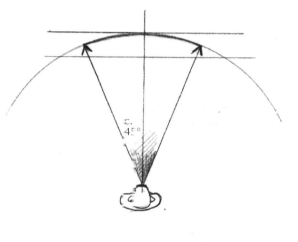

1

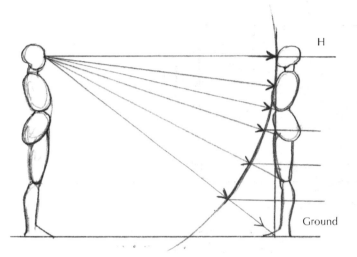

2

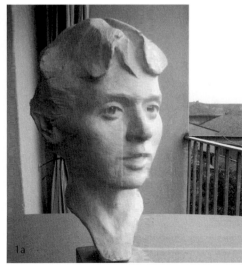

1a

2a

I took the distorted photographs (1 and 1a) by bringing the normal lens of an ordinary digital camera close to the object. For the corrected photos (2 and 2a), I increased the distance from the object and made use of a low-powered zoom lens. Although contortions of perspective can still be seen in the corrected versions, they have been reduced sufficiently.

## SPATIAL RECESSION AND DEPTH PERCEPTION

The objects that fill our field of view may be at varying distances but we perceive them accurately. The same indicators that we use in perceiving these spatial relations correctly can also help us depict them effectively in our drawings. Some examples include:

- The degree of detail used – objects closer to the viewer are richer in features and in sharper focus than those further away.

- Size – nearer objects appear larger than those in the distance.
- Overlapping or occlusion – an object that is partly covering or blocking another one places the blocked object further back.
- Tonal intensity – tones are strong in areas closer to the observer.

Detail

Size

Overlapping

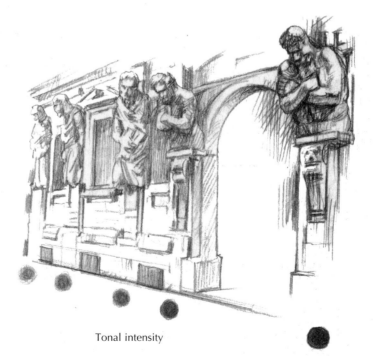

Tonal intensity

## DECIDING WHAT TO INCLUDE AND HOW TO PLACE IT

In order to depict a subject accurately in relation to the picture space, you should do a few preliminary actions before starting the drawing. For example, you need to decide on the framing – which part of the environment or object do you wish to bring into the visual cone and into the picture? It is also necessary to assess the relative size of each object or group of objects – or at least their maximum height and width.

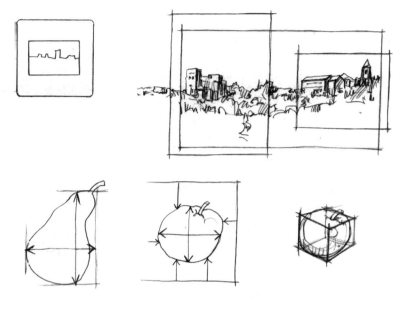

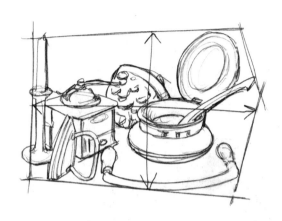

## USING THE SQUARE AS A UNIT OF MEASUREMENT

The square, (and its three-dimensional counterpart, the cube), is a primary geometrical form which is widely used to facilitate the process of assessing dimensions and relations within complex objects and architectural constructions. Squares are easy to discern in any image or environment and they can be used as a benchmark unit with which to break down the whole object into smaller shapes, thereby making it easier to recognise directions and proportions both of the whole object and of its component parts.

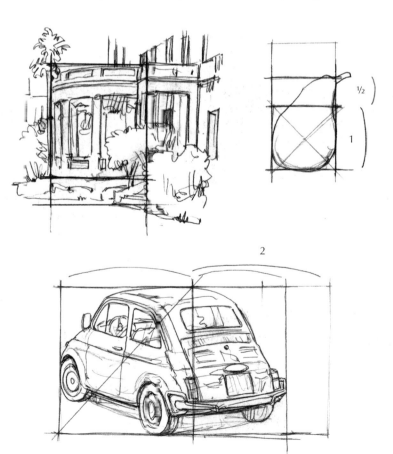

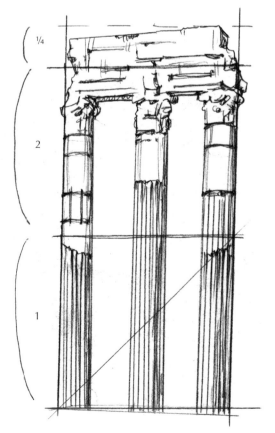

## THE STAGES OF DRAWING FROM LIFE

When looking at the subject of your picture (or a photograph of it), try working through the following steps:

1 Identify the structural lines, both horizontal and vertical and the level of the horizon.

2 Indicate the most important structural forms and the angles of the lines of perspective.
3 Introduce the prominent details.
4 Define the minor details and the areas of light and shade.

The two examples below should be sufficiently clear in the way they indicate progression through different levels of observation. The subjects are very different from one another, but they share a need for careful investigation of perspective.

1

2

3

4

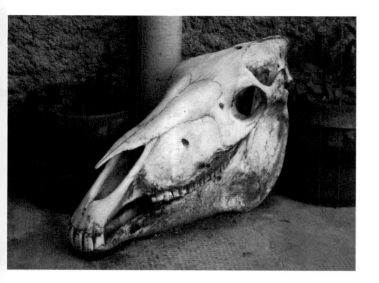

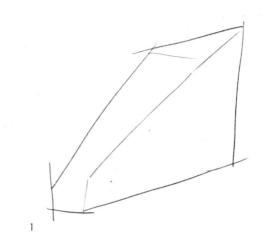

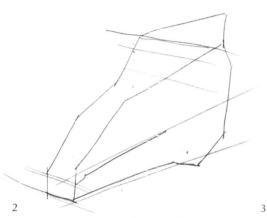

1

2

3

4

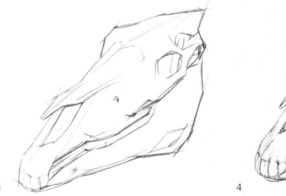

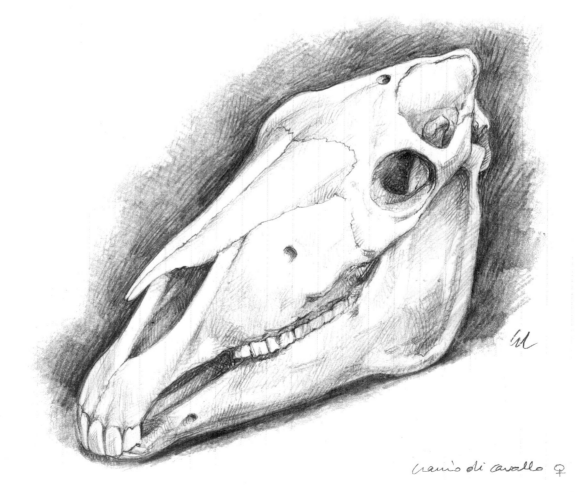

cranio di cavallo ♀

# AERIAL PERSPECTIVE

When dealing with perspective, it is important to take into account the effect of the atmosphere over increasing distance. This is most noticeable in pictures of extensive areas of landscape, whether rural or urban. In such studies, not all of the spatial effects can be rendered by linear perspective alone. Atmospheric conditions mean that objects do not just look smaller the further away they are but they also become less sharp. Their detail decreases and their colours lose intensity, causing them to become tonally lighter. Vapour and dust in the air cause these effects, which are intensified the further away the object is from the observer. This is known as aerial (or tonal) perspective.

The tonal gradation shown below and the accompanying photographs illustrate this principle quite effectively: clarity of detail and tonal intensity in the foreground gradually give way to blurred outlines and a reduction in chromatic intensity through the middle ground and into the background.

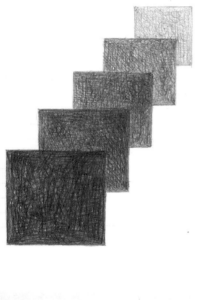

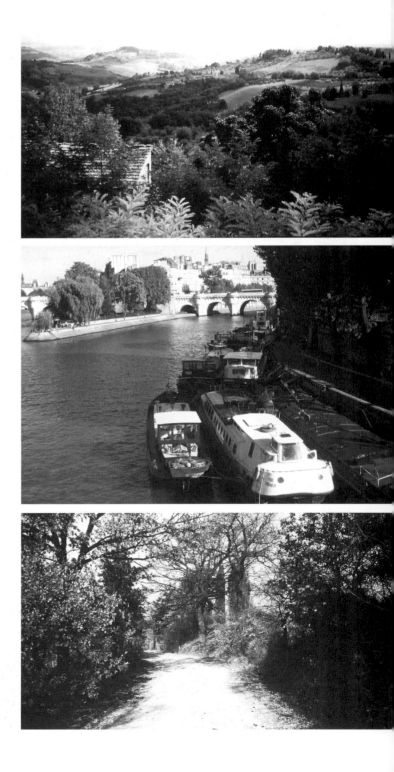

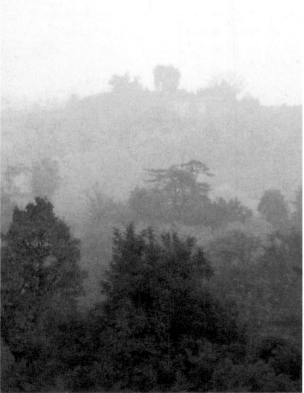

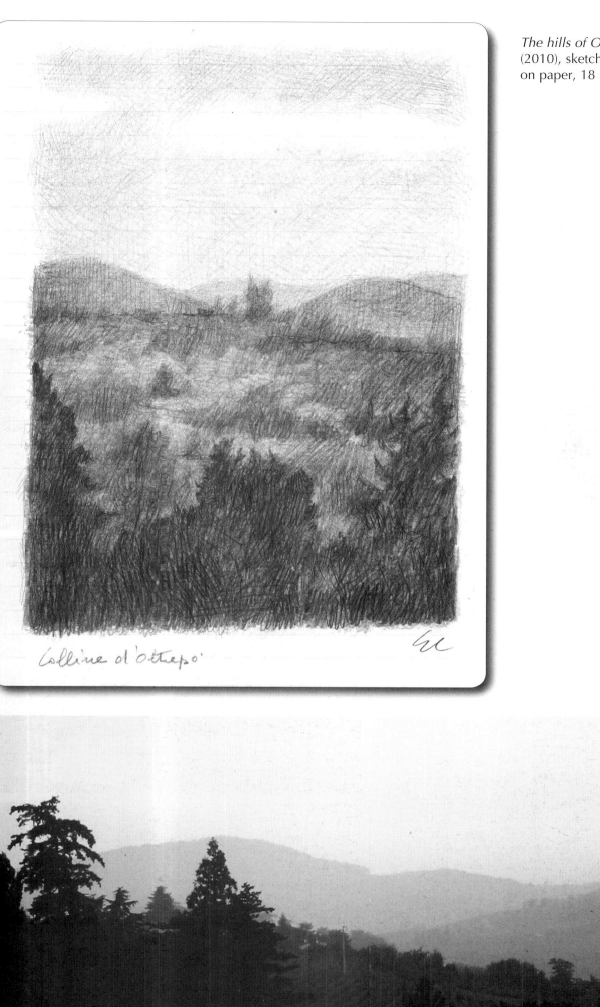

*Colline d'Oltrepò*

*The hills of Oltrepò, Casteggio* (2010), sketchbook page, pencil on paper, 18 × 23cm (7 × 9in)

# UNDERSTANDING LINEAR PERSPECTIVE

A reproduction of the apparent form of an object, as it is seen when viewed from a fixed point, has come to be known as the perspective view (from the Latin verb *perspicere*: to see into the distance or to see clearly). By 'natural' perspective we mean the way our eyes perceive the dimensions of various objects and the spatial relations between them. This is achieved by means of binocular vision. Our natural perspective is adapted and applied as artificial (or linear, geometrical) perspective, which is governed by a series of simple principles, notably the following:
- The point of view is comparable to that of only one eye.
- Equal-sized objects appear to become smaller as they get further away.

- The image is created as if being drawn on a flat pane of glass (the image plane) interposed between the viewer and the object being viewed – this image plane is perpendicular to the line of vision.
- The horizon line is always at the observer's eye-level.

If you try looking at the object or the environment you intend to depict through only one eye, some of the above relationships between size and viewpoint will become easier to appreciate.

The diagrams below review some of the operations employed in perspective drawing.

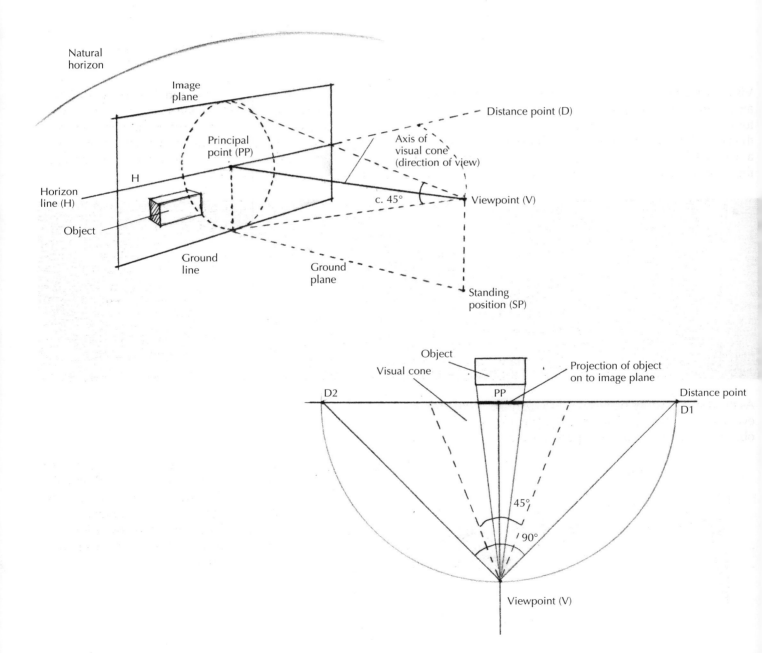

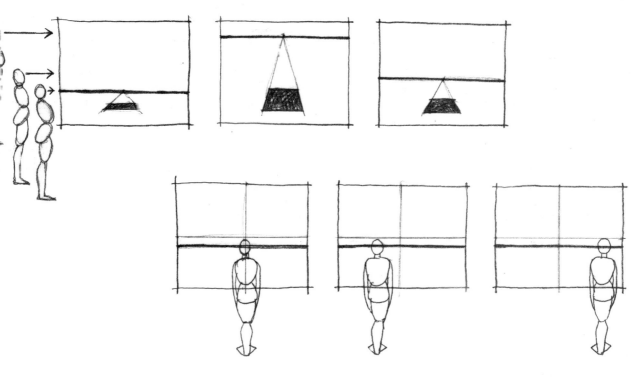

Visual perception is relative to the vertical and horizontal axes of the observer's position. These axes are related, in turn, to the observer's centre of balance and the nature of the ground surface. The perspective horizon is, of course, a horizontal line, although in special circumstances, or for the purposes of artistic expression, an artist may opt to tilt this line a little to the left or right, and therefore the whole perspective as well. People viewing such a picture tend to tilt their heads in order to re-establish the normal vertical axis, but in doing so, they will notice a dramatic tension and greater dynamism from the unorthodox viewing angle (see the photographic examples).

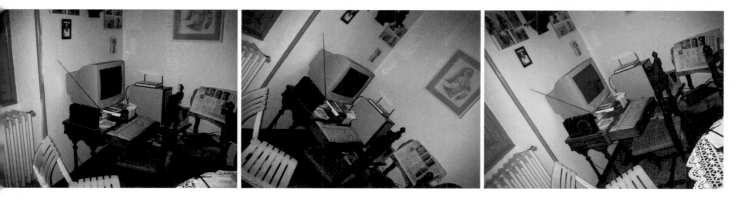

As the distance varies between the chosen viewpoint (the eye of the observer) and the image plane, the size of the object will change, but not its perspective.

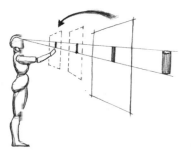

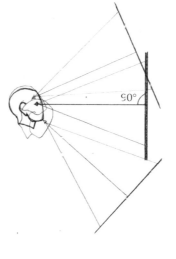

The image plane is always perpendicular (at right angles) to the axis of the visual cone and follows its orientation. Usually the observer will face the horizon and the plane is inclined upwards or downwards when their gaze moves in these directions.

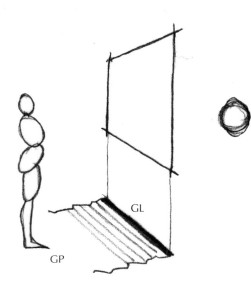

The **ground plane (GP)** is the surface on which the observer, the observed objects, and the base of the image plane are standing. The ground line (GL) is the line along which the image plane meets the ground plane.

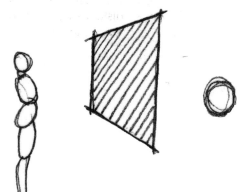

The **image plane** (the perspective plane or picture plane) represents the picture or painting surface. Think of this plane as being a sheet of glass placed between the observer and the object, which always remains perpendicular to the horizontal ground plane and perpendicular to the direction of view. This remains the case, irrespective of whether the paper on which you are drawing is angled or lying flat on a work surface. The distance between the viewpoint and the image plane can be varied at the artist's discretion.

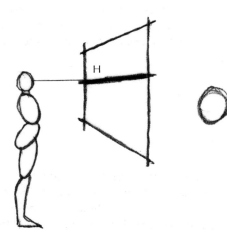

The **horizon line (H)**: the 'terminal circle' or horizon is the circular line that marks the limits of the earth's surface visible to the eye of an observer. It is represented by a (horizontal) line that crosses the picture at the observer's eye-level (viewpoint). The horizon line is also the location of the **vanishing points** (points of convergence), which are the points at which all straight horizontal lines that are parallel to each other would meet if they were extended into the horizon. If these lines meet the image plane at 90°, there is a single vanishing point, which coincides with the **principal point**; if they are at a 45° angle, the vanishing points coincide with the **distance points**. For lines remaining parallel to the ground plane but meeting the image plane at other angles, the vanishing point is correlated to this angle of incidence. Each object in a composition can, depending on its position and orientation, have its own vanishing points and there may be many such vanishing points in the same perspective picture. In the case of two-point perspective, there are at least two vanishing points, each located on the horizon line on either side of the central line of vision (or median line), while in the case of three-point perspective, vanishing points are also added on the median line above and below the horizon line.

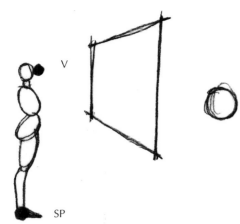

The **viewpoint (V)**, or observation point, and the **standing position (SP)** are, respectively, the location of the observer's eye and the place on the ground plane at which the observer is standing. The standing position is always perpendicular to the viewpoint.

The **distance** between the observer and the image plane determines the positioning within the frame, i.e. the size of the objects in the picture and their projection on to the image frame. When an eye at a fixed level moves closer to the object, the size of that object is increased on the image plane. In standard conditions, the artist's distance from the image plane (e.g. the sheet of paper) is equivalent to an arm's length.

Visual rays are imaginary rays reaching out from the motionless observer's eye to touch all objects being observed. Taken together, these rays form the **visual (or optic) cone**, the apex of which has an angle of up to but not greater than 45° either side of the direction of view, or central axis. The **principal point (PP)**, or centre of vision, is the projection of the viewpoint on to the horizon line and it is therefore the point at which the **direction of view** pierces the image plane.

At any one time, our eyes can only focus on those objects lying within an angle of vision of between 15° and 25° on each side of the direction of view. If you wish to look at an object lying outside your initial visual cone, you will have to change your viewpoint and this will change the direction of view. For this reason, all the objects you intend to include in a perspective study must lie within this visual cone.

Some of these elements to aid in the rendering of perspective are optional, and some elements can be changed, such as the observer's position (viewpoint), the level of the viewpoint (horizon line), the distance of the observer from the image plane and the observer's distance from the object.

# CENTRAL LINEAR PERSPECTIVE

Central linear perspective (sometimes called parallel, frontal or single vanishing-point perspective) is based on the principle of a single point of convergence in a central position on the image plane (the picture surface). All parallel, non-vertical lines converge on this point as they head into the distance. The horizon line will always correspond to the observer's eye-level and will be determined by the viewpoint, i.e. the position from which the object is being observed. In central perspective, one of the sides of the drawn object, (which may be a house, a cube or a box, etc.), will be parallel to the side of the image plane, while perpendicular lines to the image plane and to the observer converge on a single point on the horizon line (point PP). Vertical lines remain vertical in this perspective scheme and lines that are parallel to the base of the image plane remain parallel to the horizon line. All other lines converge on the single vanishing point.

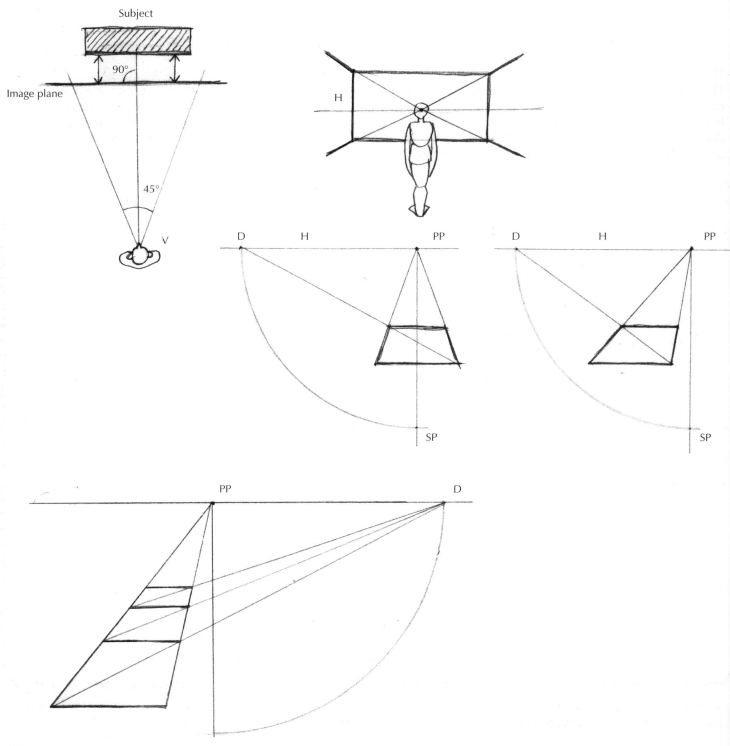

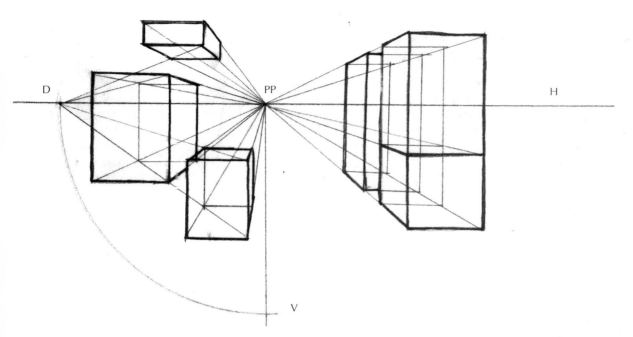

These diagrams illustrate how central perspective works. The distance point (D) is used for determining the depth dimension of a geometric figure. It is positioned on the horizon line along from the principal point (PP) and its distance from the PP avoids excessive distortions. The distance between D and the principal point is the same as the distance from the viewpoint (V) to the PP. This distance point lies, therefore, on the circumference of a circle of the same radius or can be found by drawing a line from the standing position to the horizon line at an angle of 45° to the vertical formed between the principle point and the standing position.

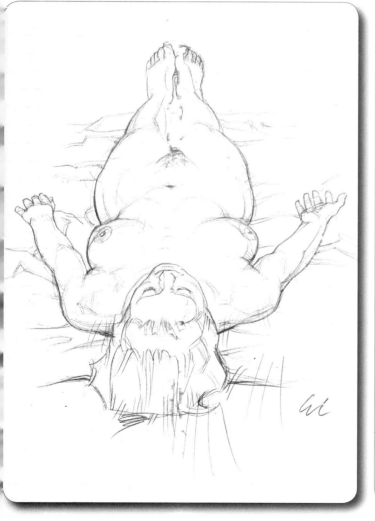

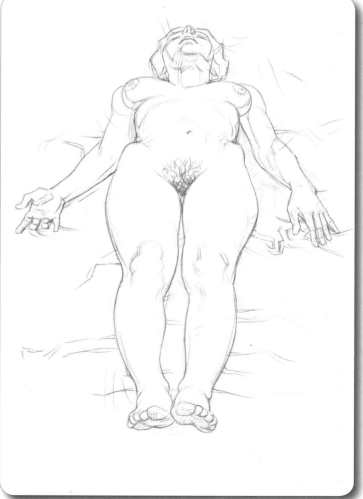

A complex subject such as the human figure lends itself to the use of the principles of central perspective. This can be aided by imagining the model inside a solid box, or, alternatively, imagining that the model is reclining on a rectangle.

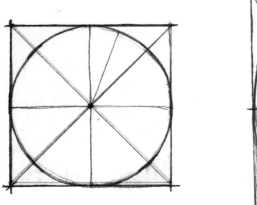

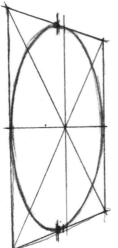

Drawing a circle in perspective (which produces an ellipse) is easier if it is drawn in a perspective square (which produces a trapezium). Begin by drawing the central and diagonal lines. You will notice that the major axis of the ellipse is not the same length as the diameter of the original circle.

The height of the ellipse will vary according to its relative position to the horizon line. It progressively diminishes as the circle approaches this line. This factor needs to be carefully evaluated when drawing cylindrical forms – whether manufactured ones such as bottles, columns, glasses, musical instruments, etc. or natural forms such as tree trunks, arms or legs of people and animals.

An easy approach to drawing a circle freehand is to insert its axes in a square frame and then 'rotate' its radius. See also Thales theorem, page 29.

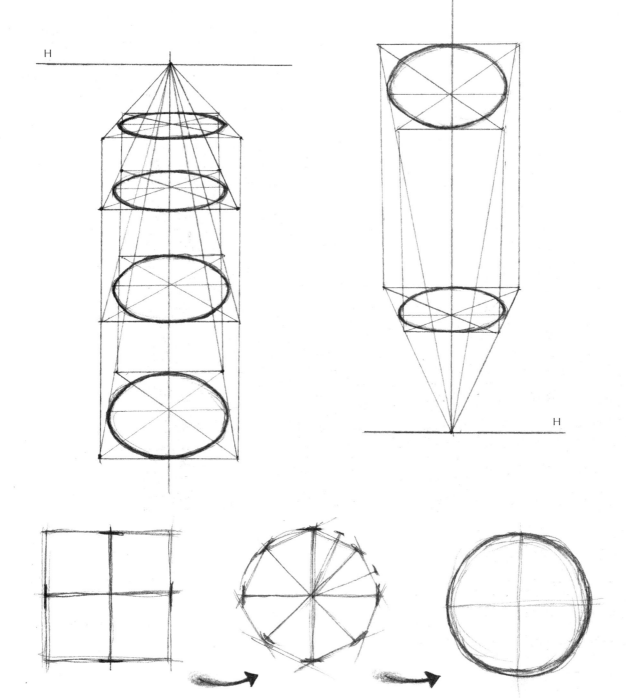

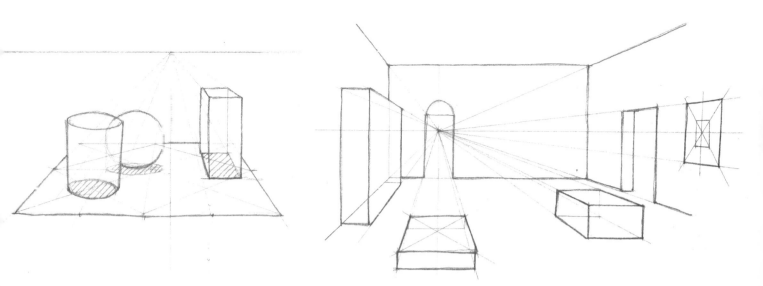

When applying perspective techniques in a freehand drawing from life, it is a good idea to simplify the process of analysis by breaking it down into several steps. For example:

1 Choose a suitable viewpoint for an effective division of the compositional frame
2 Check that your chosen frame caters for the dimensions and format of the sheet of paper on which you are drawing: you can do this by holding the sheet out vertically at arm's length and imagining that the central axis of your direction of vision passes through its centre.

3 Choose the type of linear perspective (central, two-point, etc.) that appears most appropriate for the needs of your subject.
4 Decide on an approximate perspective scale of measurement and orientation and set the vanishing point(s).
5 Sketch out the main vertical lines and the outlines of the objects, estimating their relative dimensions and proportions and applying the basic rules of perspective to verify the orientation and angle of the lines heading towards the vanishing points.

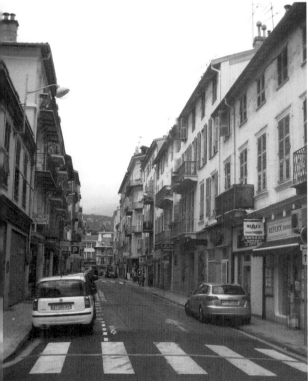

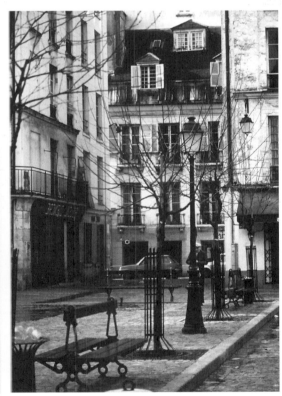

The use of central perspective would be ideal for subjects such as those shown in these photographs.

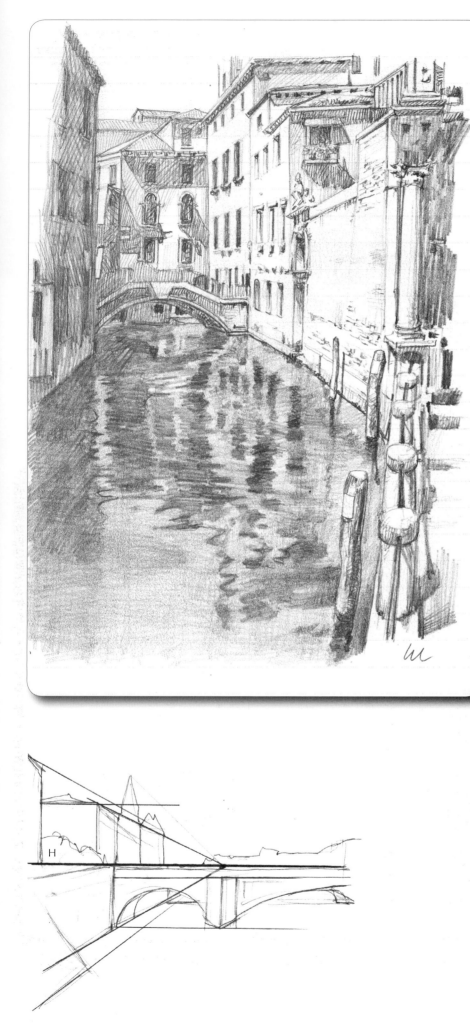

*Venice* (2009), pencil on paper,
18 × 23cm (7 × 9in)

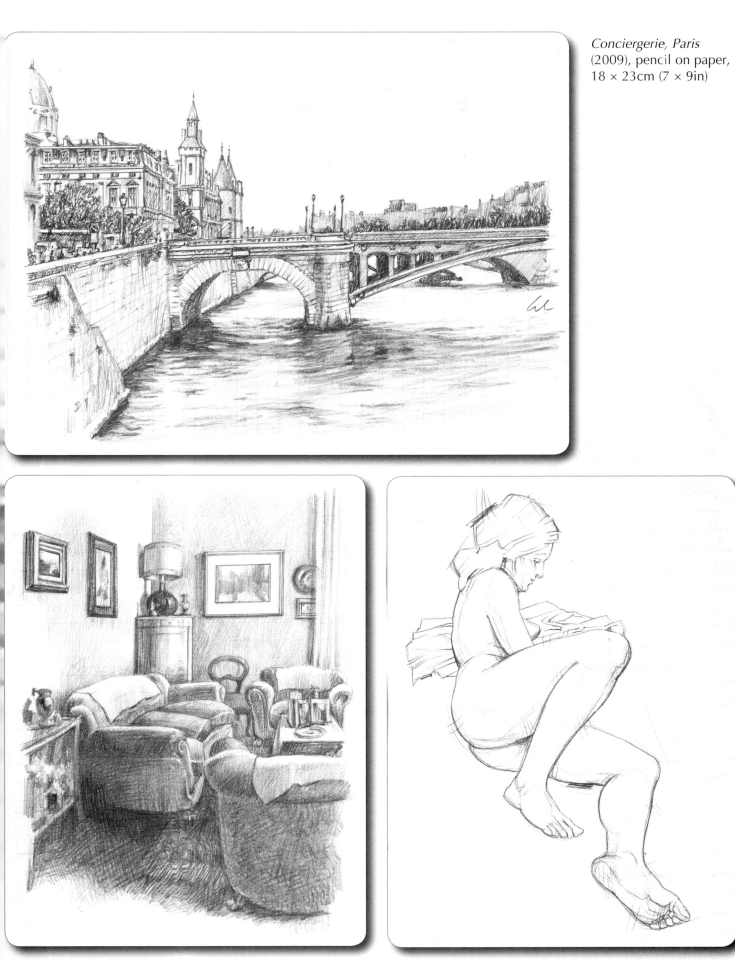

Conciergerie, Paris (2009), pencil on paper, 18 × 23cm (7 × 9in)

Interior of my house (2009), pencil on paper, 18 × 23cm (7 × 9 n)

Elsa (2009), pencil on paper, 18 × 23cm (7 × 9in)

# TWO-POINT LINEAR PERSPECTIVE

Two-point linear perspective (also known as oblique, angular or incidental perspective) allows objects to be positioned obliquely to the image plane, i.e., objects viewed from a corner-facing angle, with all of their sides shortened. The observer's position is typically off-centre. This type of perspective therefore covers what is a very frequent observational stance for artistic representation.

As with other perspective schemes, the horizon line is always situated at the observer's eye-level and may be placed at various levels on the paper, while vertical lines keep their verticality. With central perspective, the main benchmarks were the viewpoint (V) and the distance point (D). In two-point perspective, however, these points are of secondary importance. With this method, the dimensions and forms of objects are determined using the vanishing points (VPs). There are two vanishing points: one located to the left and one to the right of the observer somewhere farther along the horizon line. All of the non-vertical lines on each side of an object converge towards one of these points (this is, of course, what gives the object its shortened appearance), and the sides appear to shrink in height as they recede into the distance. There are at least two vanishing points, although more than two may be used as any object in a complex composition which is not standing parallel to the others will require its own specific vanishing points on the horizon line. Additionally, vanishing points may be located above or below the horizon line when you want to depict inclined planes such as roofs, stairways and steep roads.

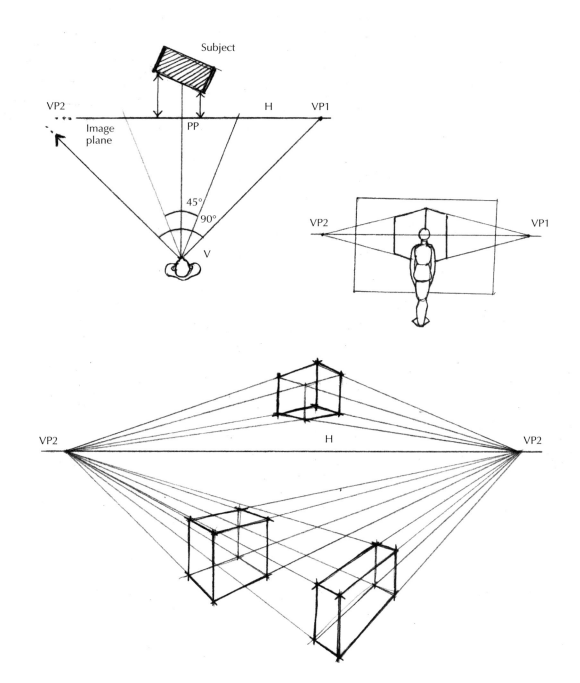

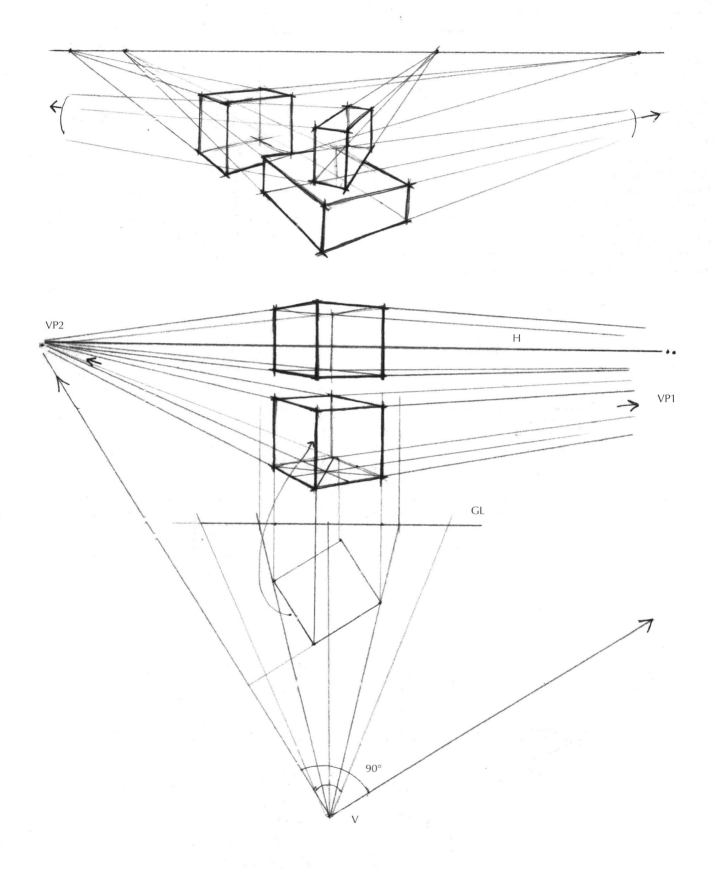

The diagrams contain the following labels: VP2, H, VP1, GL, 90°, V

These diagrams illustrate some common uses of two-point perspective in artistic work.

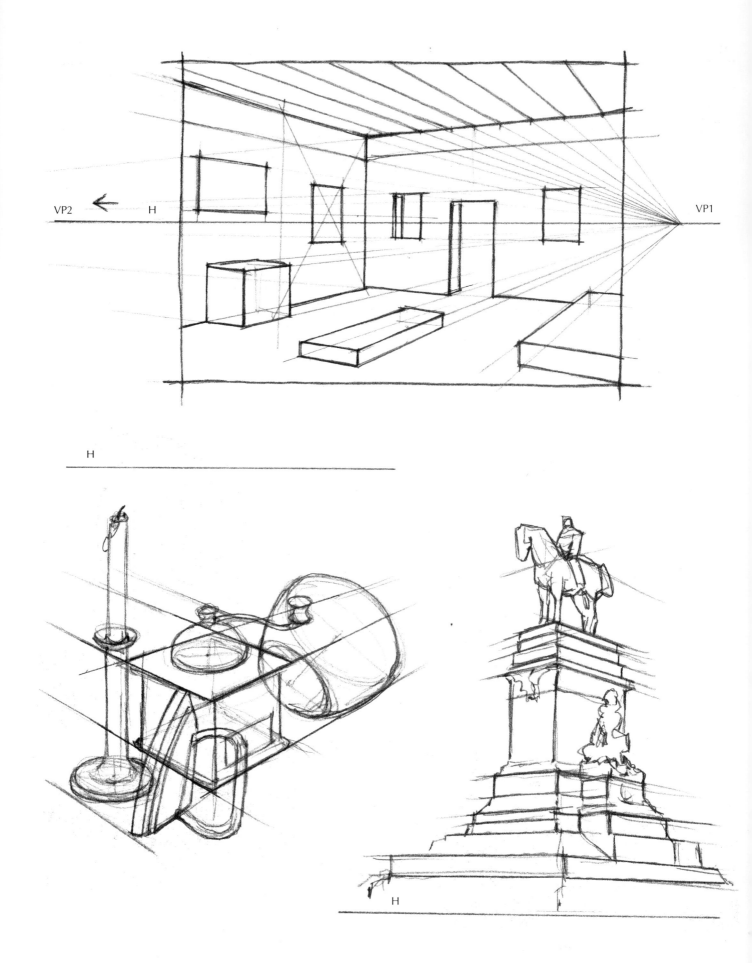

VP2 ← H

VP1

H

H

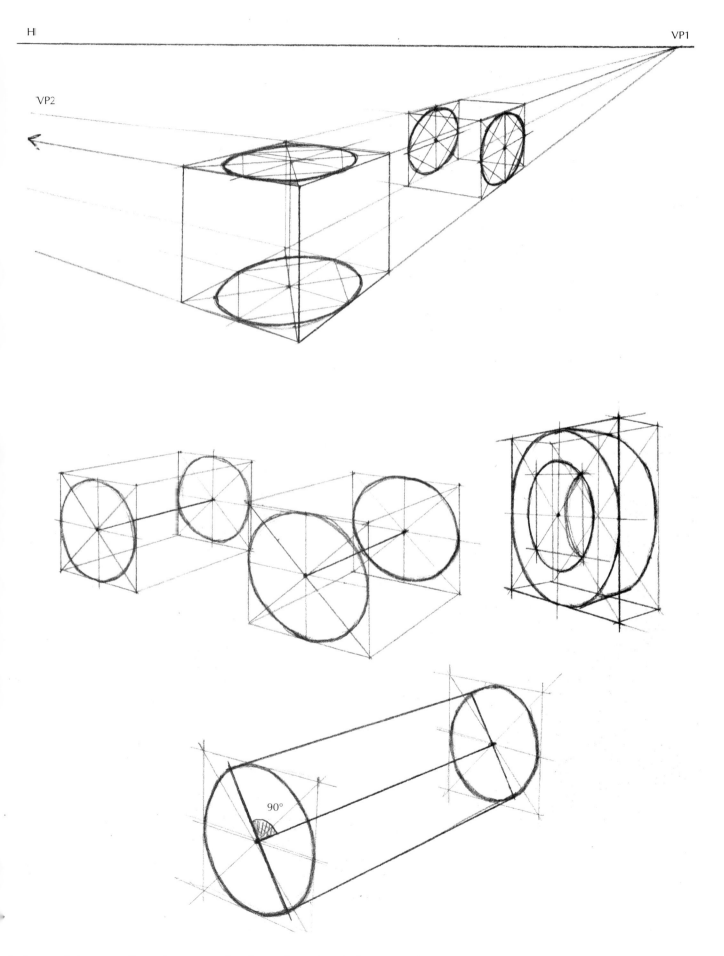

In two-point perspective, circles may be drawn by using their perspective squares.

When subdividing a straight line or surface into two or more equal sections, it can be helpful to use the diagonals of a geometrical shape (square, rectangle, etc.) which corresponds to the section of the line that you wish to divide, repeating the operation for each section.

This procedure is also useful when drawing architectural studies freehand from life, for example, when you need to position doors, windows and other features correctly in relation to the building's façade.

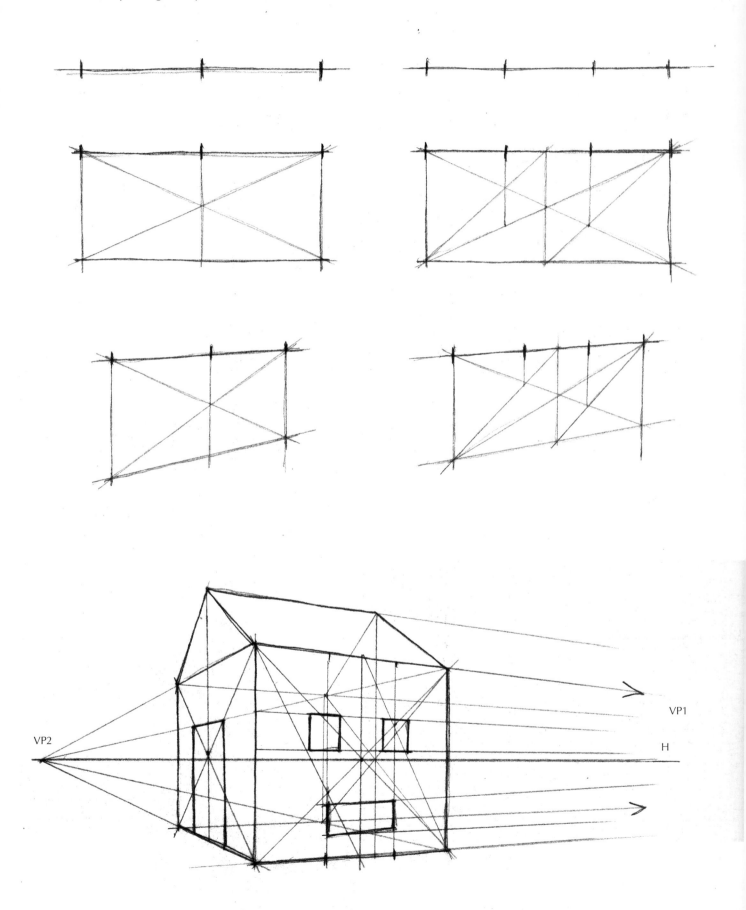

**Thales' theorem** on triangular proportionality is a very practical method for subdividing a surface into equal or unequal segments, and it can be used as a guide for delineating a procession of arches, for example. It can be applied in the following steps:

1 Plot the main lines of perspective.

2 Divide the straight line defined by the diagonals into segments of equal length on each side of the median (the vertical central line between the viewpoint and principal point).

3 Locate the surface segments by projecting upwards from the intersection of each segment's diagonal.

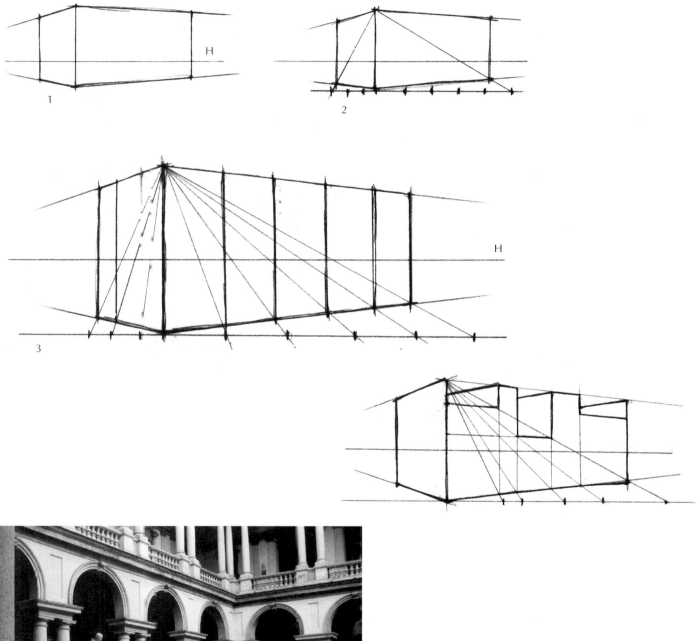

The diagrams which follow suggest further simple and intuitive methods for dividing a surface in perspective projection into equal segments.

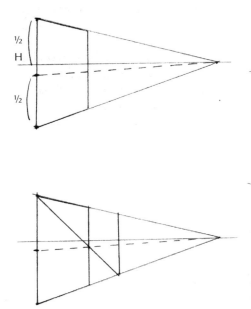
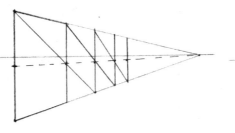
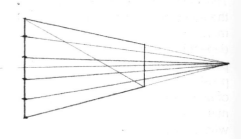
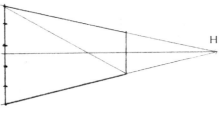
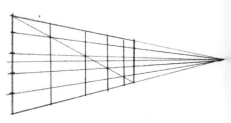

The height of the human figure (or of each figure in a group in relation to the others, based on figures of similar stature), appears to decrease in relation to its distance from the observer and its position on the ground plane.

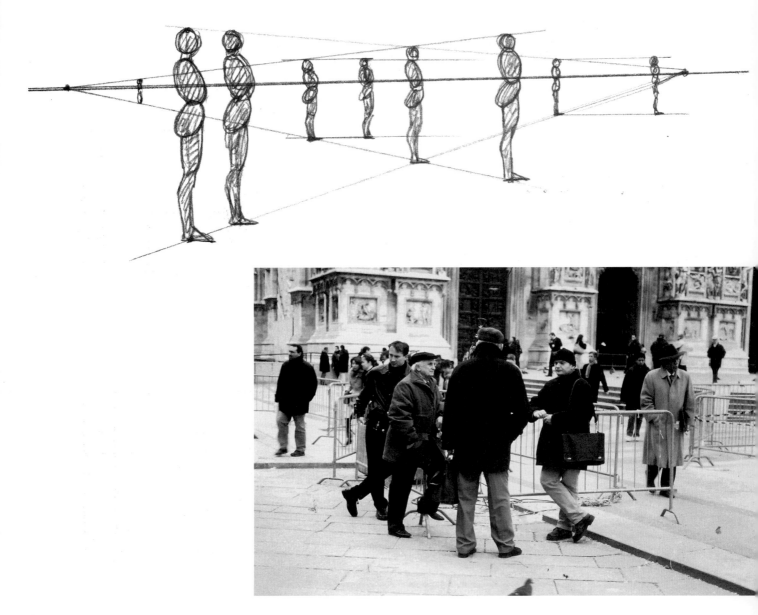

The vanishing points (VPs) are nearly always located outside the frame of the composition, a large distance from the margins of the picture surface. Their precise location varies depending on the object being drawn and the observer's position in relation to that object. In such cases, it is possible to locate the vanishing points with a fair degree of precision just by using your judgement in extending the main perspective lines which form the object's outline to where your eye tells you they will meet. Use the following steps for a more accurate method:

1 Divide the vertical line that represents the corner of the object nearest to the observer into any number of equal segments.
2 Draw the lines which form the edges of the two oblique faces, estimating their approximate inclinations.
3 Project the same number of segments on to another vertical line drawn near the margin or on the margin itself. This procedure can be adapted for drawing architectural interiors.

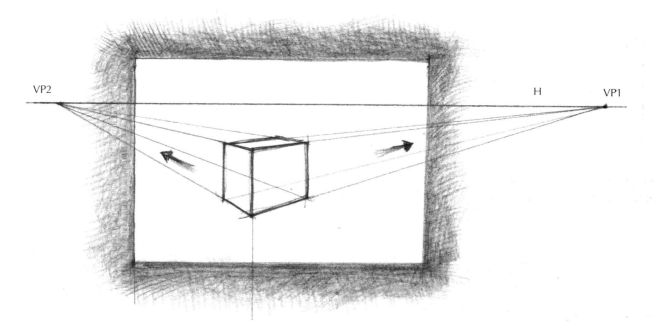

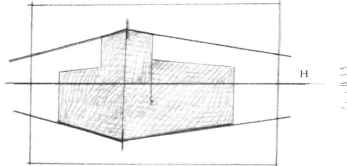

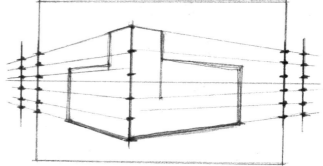

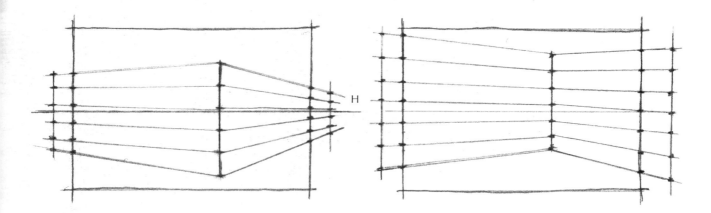

31

The various planes that make up a complex object may be inclined at different angles to the ground plane, which is always assumed to be parallel to the horizon line. The vanishing points of such inclined planes are therefore not found on the horizon line but above or below it, at heights that will reflect the degree of the angle of the inclined plane in question. If there are many such inclined planes with different slants in a composition, there will be many vanishing points. These points (marked Pa, Pb and so on on the diagrams) are, however, always located on a vertical line which projects from the horizon line and the point of intersection of this vertical with the horizon line will be the vanishing point derived from a horizontal, non-inclined plane.

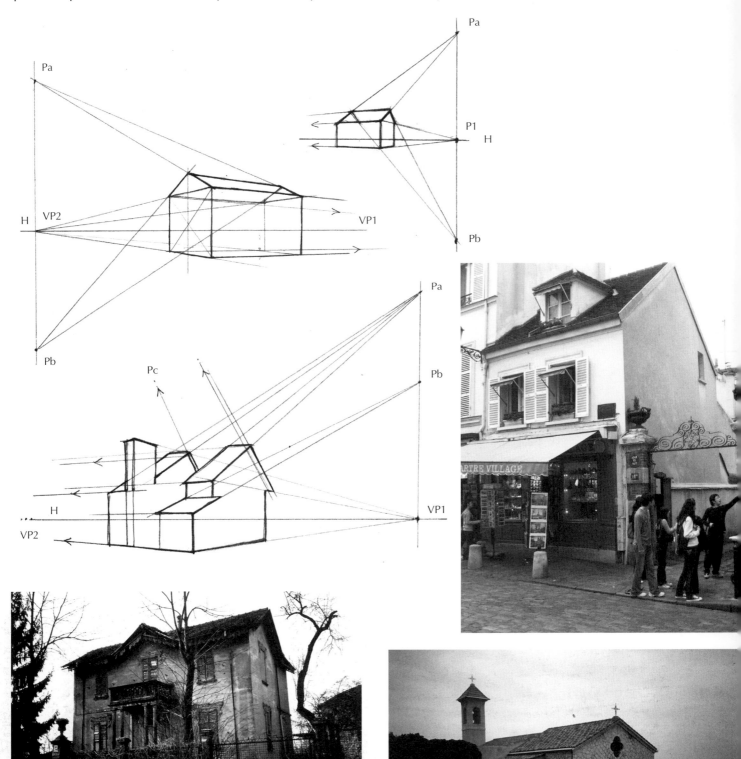

Pa

VP1

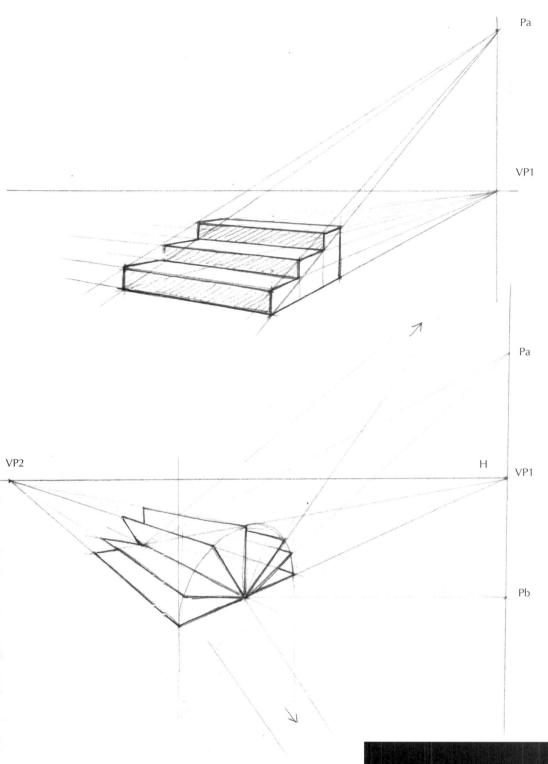

Pa

H          VP1

VP2

Pb

Inclining planes each have their own vanishing points located at different places on the horizon line, each of which correlates to the plane's incline.

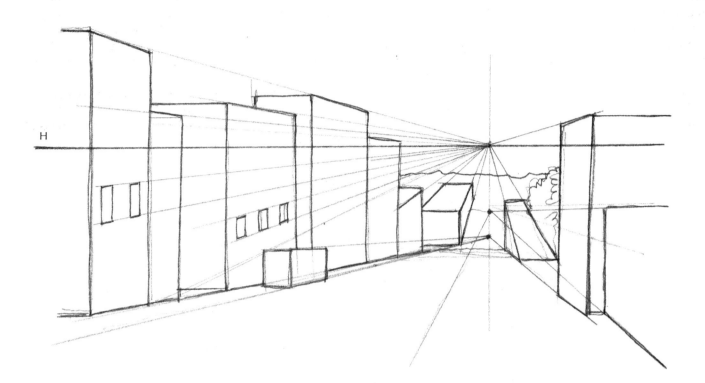

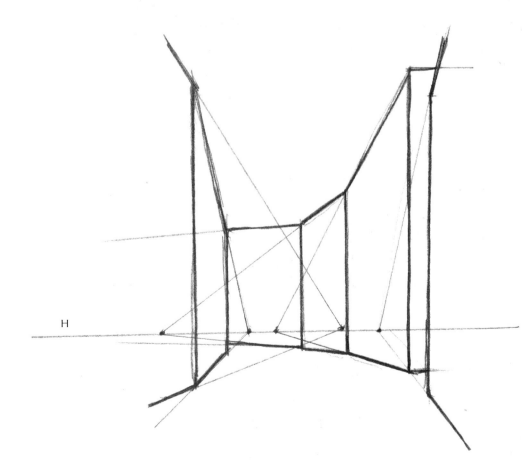

When drawing objects, figures or environments freehand and in perspective, it is easy to make errors that can distort your subject and lead to unsatisfactory results. Linear perspective does not accurately correspond to our natural vision, which is, indeed, more complex. Linear perspective 'corrects' and simplifies our vision, making it more rational. However, it should be added that it is by no means absolutely necessary – nor even useful – to apply linear perspective with unbending rigour. On the contrary, it is advisable to make adjustments to its rules and allow yourself artistic licence in the interest of improving the aesthetic result.

In the following diagrams, I have put together a few perspective howlers that are best avoided, exaggerating them a little in each case. The examples show the following:

- How the heights of figures should be in proportion to objects and buildings in the environment – each feature depicted in the drawing should be in keeping with the drawing's overall perspective scheme.
- How, if the object is too close to the observer. or its vanishing points are not far enough apart, the resulting image will appear distorted to some degree, especially if it consists of recognisable geometric shapes.
- How cylindrical forms should show the correct relationship between the series of ellipses that make up their structure.
- How straight lines, angles, verticals, horizontals, etc. should be drawn precisely and steadily, even when working freehand, paying particular attention to points of juncture and the resultant angles.

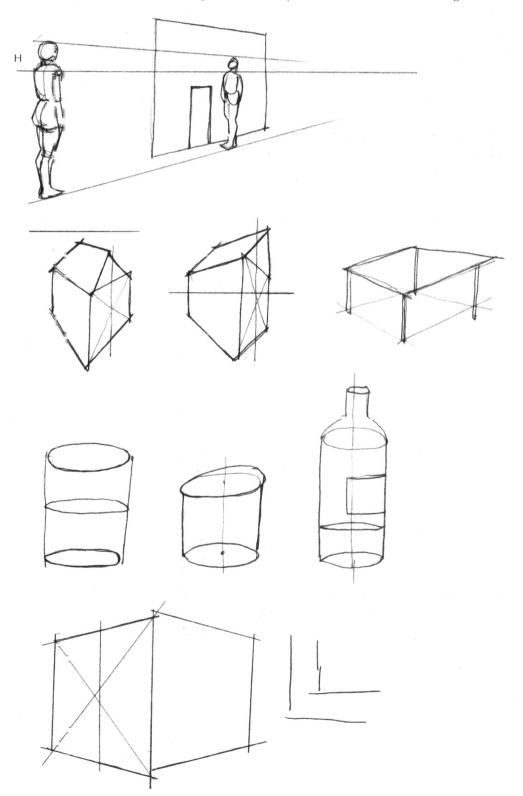

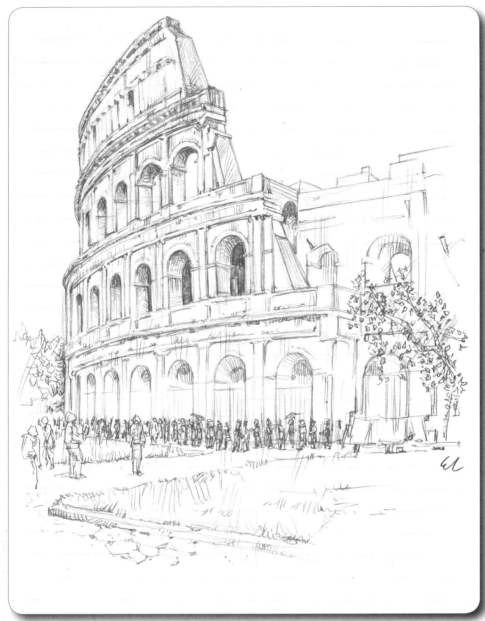

*Colosseum, Rome* (2009), pencil on paper, 18 × 23cm (7 × 9in)

*Classic car* (2010), pencil on paper, 18 × 23cm (7 × 9in)

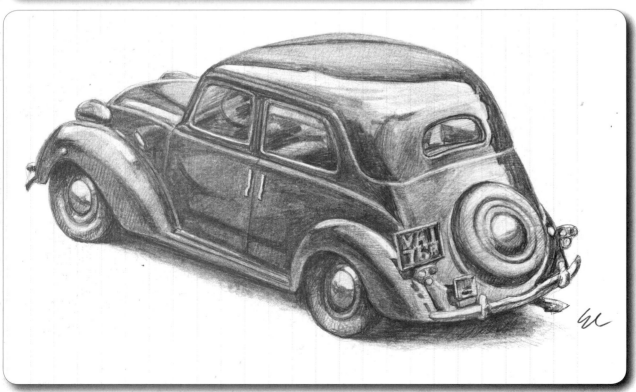

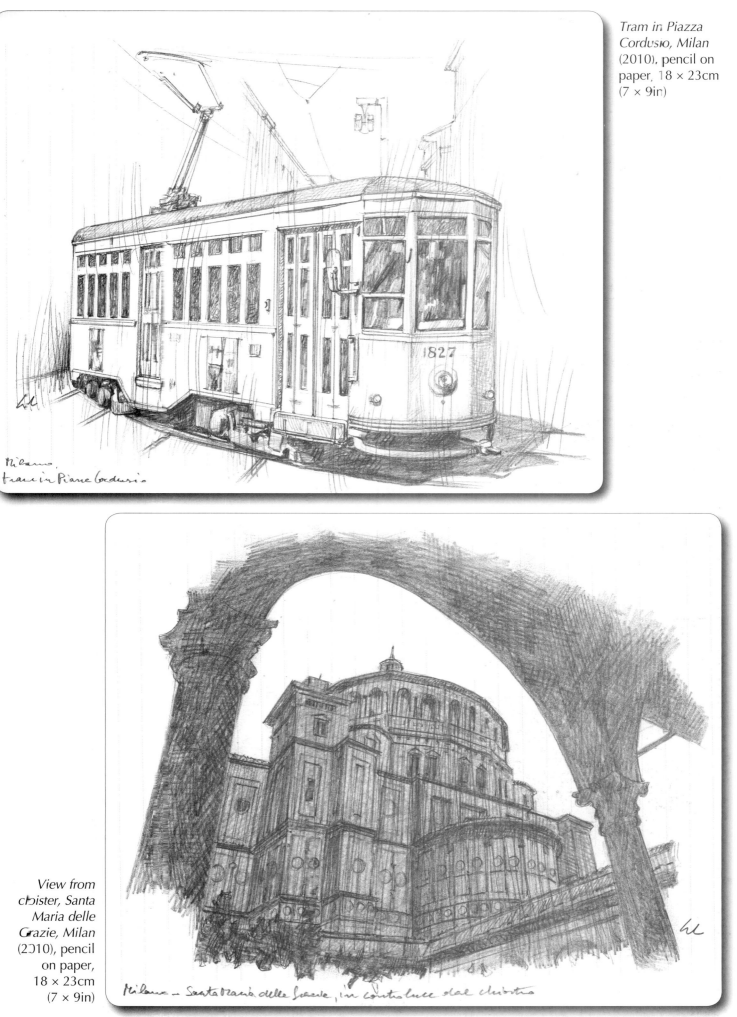

*Tram in Piazza Cordusio, Milan* (2010), pencil on paper, 18 × 23cm (7 × 9in)

*View from cloister, Santa Maria delle Grazie, Milan* (2010), pencil on paper, 18 × 23cm (7 × 9in)

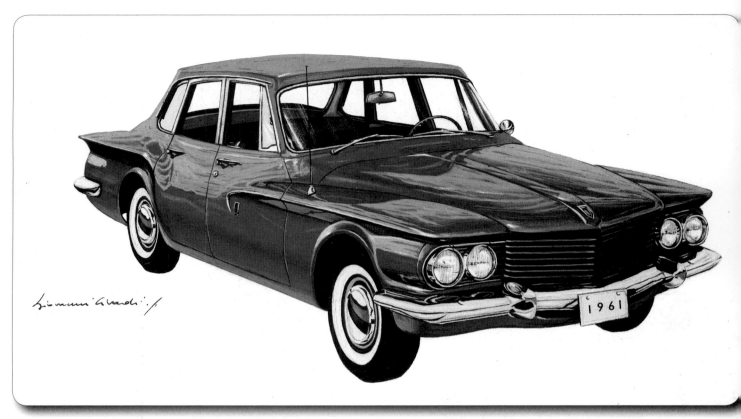

*Car* (book illustration, 1972), gouache on card, 25 × 36cm (9¾ × 14¼in)

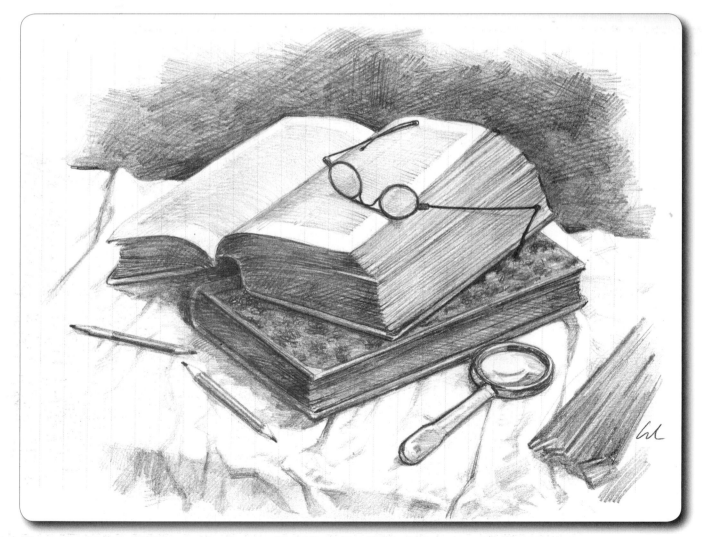

*The tools of culture* (2010), pencil on paper, 18 × 23cm (7 × 9in)

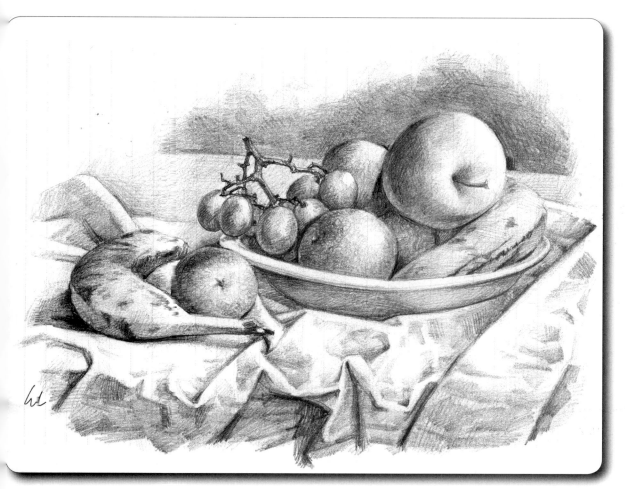

*Fruit* (2010), pencil on paper 18 × 23cm (7 × 9in)

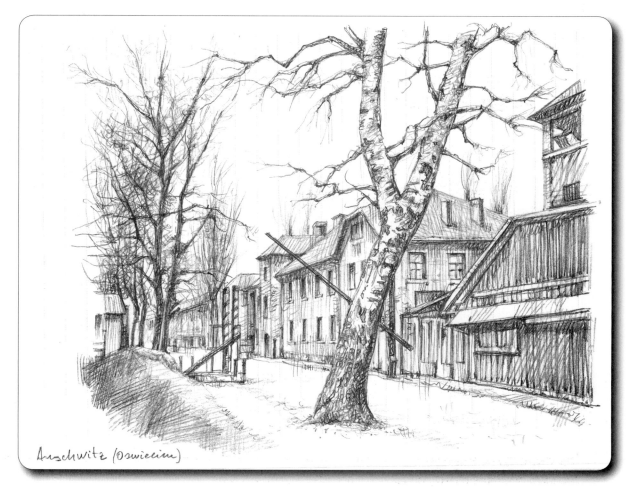

*Oswięcim (Auschwitz)* (2005), pencil on paper, 17 × 21cm (6¾ × 8¼in)

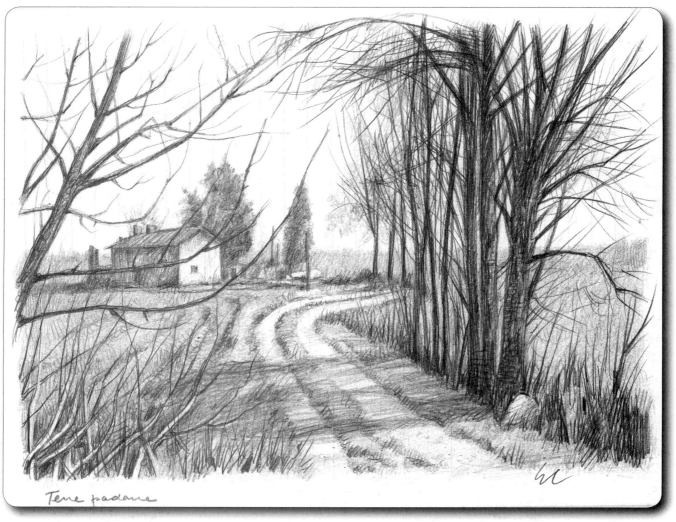

*Landscape of the Po Valley* (2010), pencil on paper, 18 × 23cm (7 × 9in)

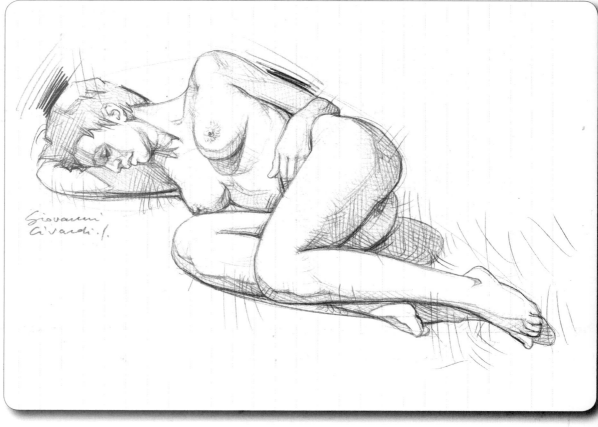

*Cinthya* (2009), pencil on paper, 18 × 23cm (7 × 9in)

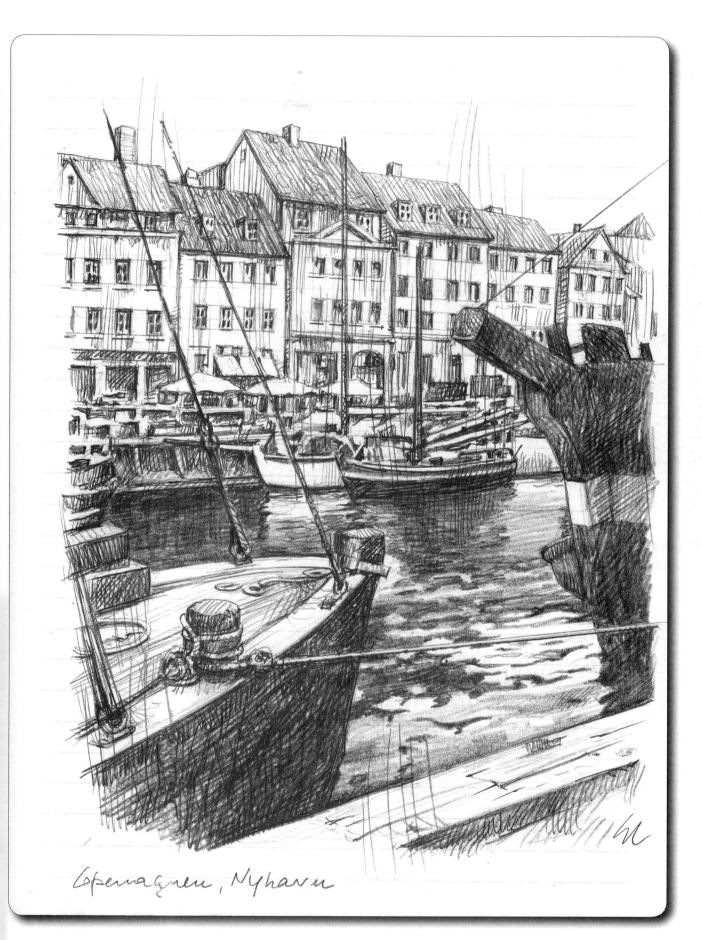

Copenagren, Nyhavn

*Nyhavn, Copenhagen* (2006), pencil on paper, 17 × 21cm (6¾ × 8¼in)

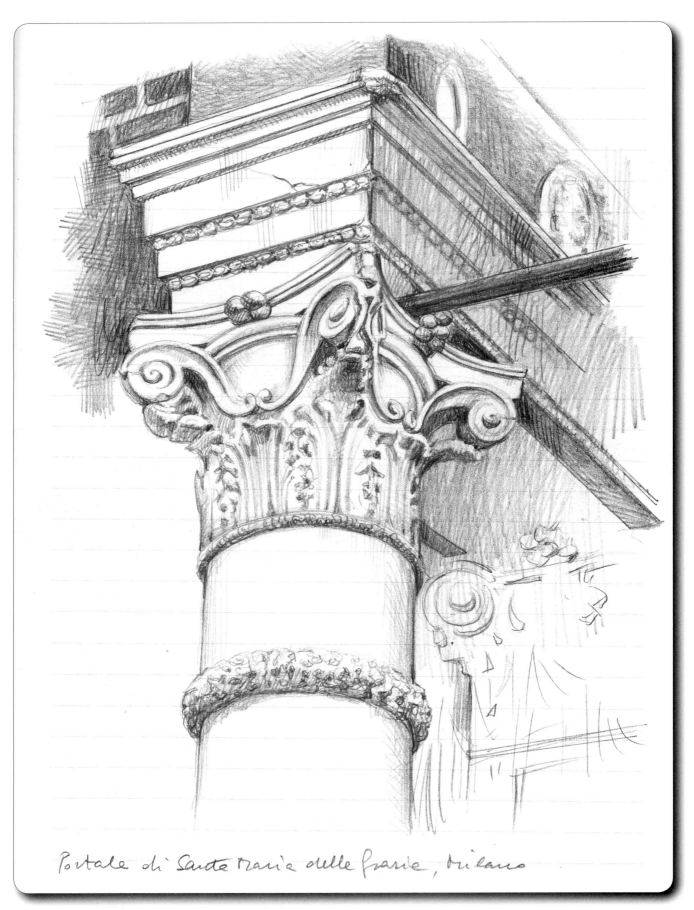

*Portal from Santa Maria delle Grazie, Milan* (2010), pencil on paper, 18 × 23cm (7 × 9in)

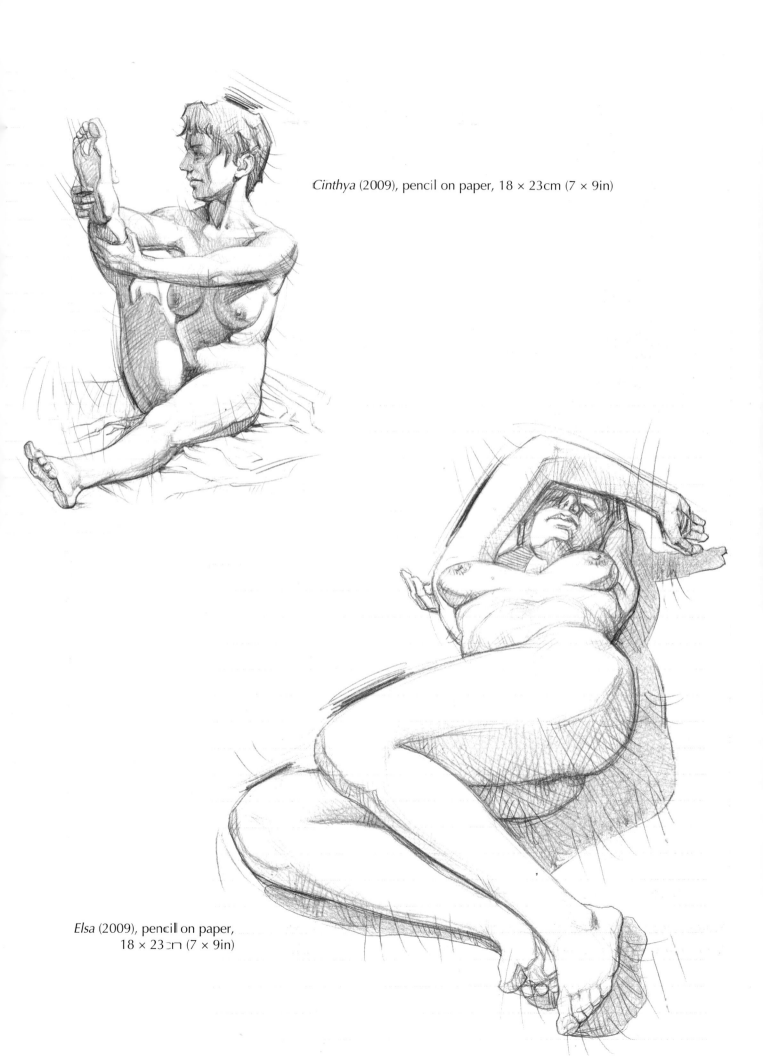

*Cinthya* (2009), pencil on paper, 18 × 23cm (7 × 9in)

*Elsa* (2009), pencil on paper,
18 × 23cm (7 × 9in)

# THREE-POINT LINEAR PERSPECTIVE

Three-point perspective is used when the observed object involves an aspect that is either very high or very deep, or when a composition is being viewed from above or from below. With the sides of the viewed object standing obliquely with respect to the image plane, it appears that the parallel lines on each side converge on three vanishing points. Two of these vanishing points are situated on the horizon line, while another point is located on a vertical line that passes more or less through the subject's central axis. This third vanishing point will be above or below the horizon line, depending on whether the viewpoint is directed from above or from below. It is best located at a distance from the horizon line that avoids the picture having an excessively distorted appearance. As with two-point perspective, three-point perspective may use many vanishing points located at various levels with respect to the horizon line, depending on the angles of the various sloping

sides that make up the complex composition. The observer's direction of view, (the centre-line of the visual cone), remains perpendicular to the image plane, but the image plane may also be inclined at various angles to the ground plane depending on variations in the standing position and direction of view.

Unlike the previous two perspective types, (central and two-point linear perspective), whose methods of calculation and usage reach back to the classical period of Western civilisation, three-point perspective is a recent development. It links new ways of looking at the world through the use of photography and through viewing objects from high above ground level, such as when flying or looking out from very tall buildings. That said, three-point perspective is very often used in depicting smaller or medium-sized objects which are seen from above, or when viewing a human figure from above or below, or from a very close viewpoint.

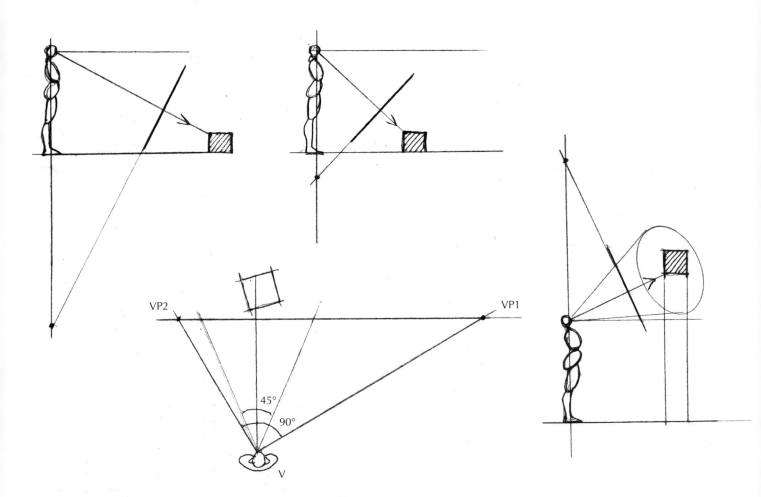

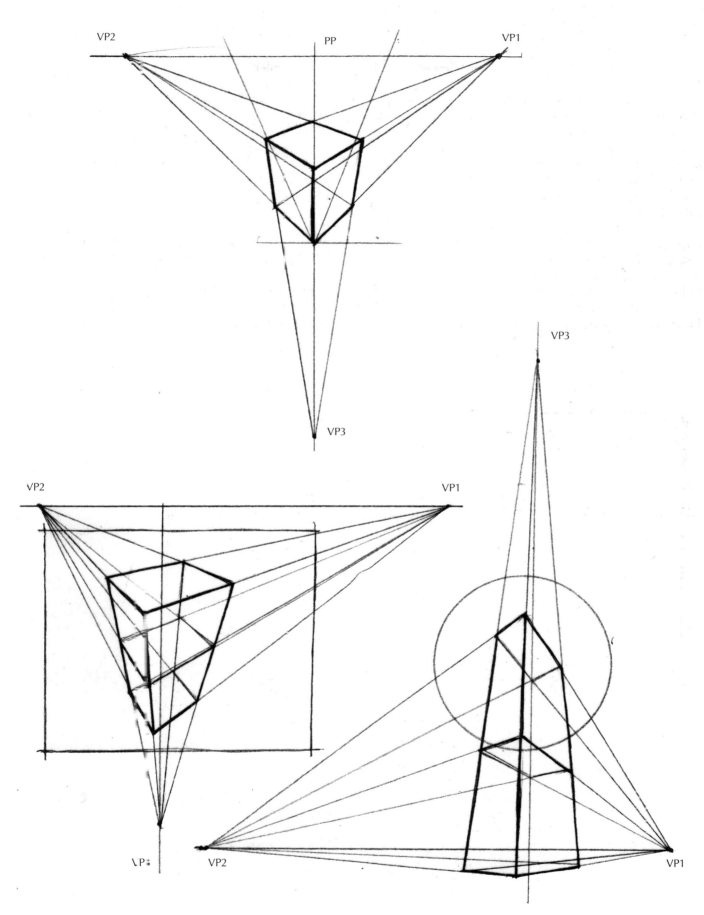

When you are looking at a very tall building from a close distance, you will only see and depict the section of the building which is within your visual cone. In other words, if you are looking at the top of a building or a column, you cannot see its base at the same time – unless you move to a sufficient distance away from the object.

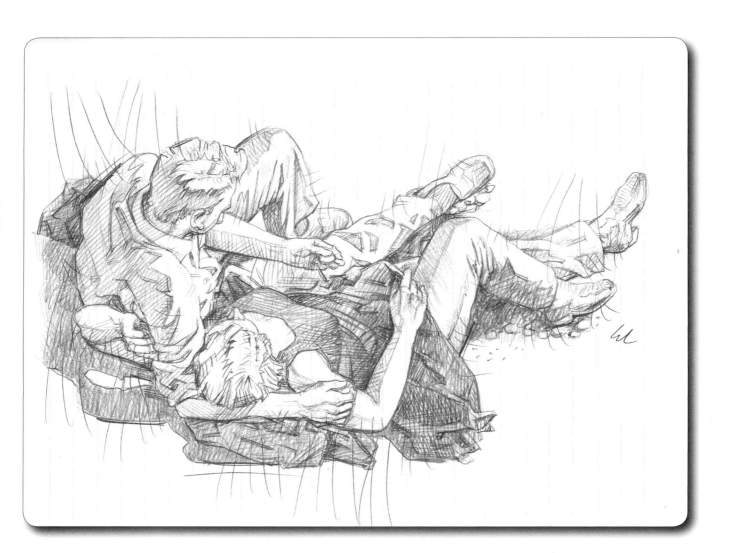

*Embrace, Nice* (2010), pencil on paper, 18 × 23cm (7 × 9in)

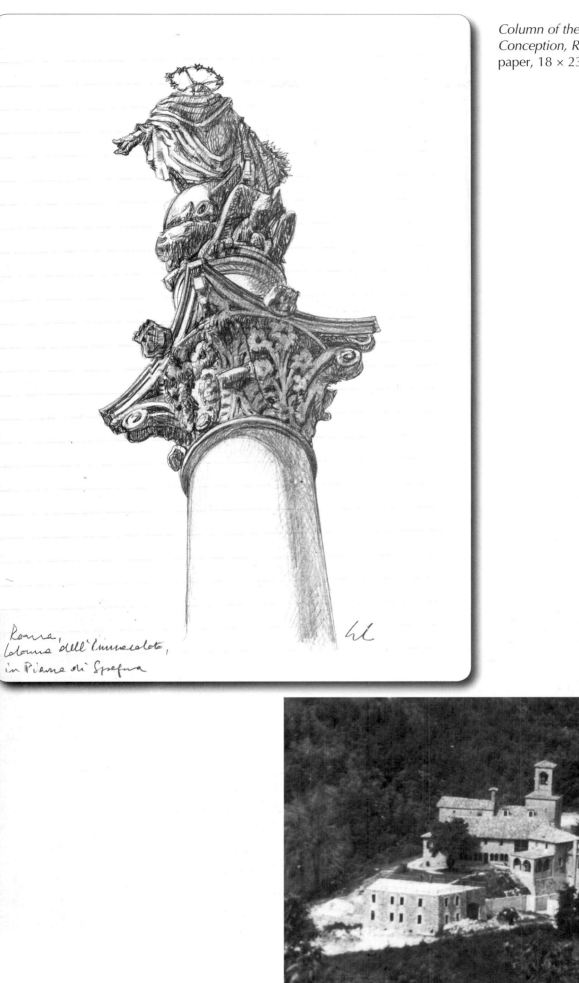

*Column of the Immaculate Conception, Rome* (2009), pencil on paper, 18 × 23cm (7 × 9in)

Roma,
Colonna dell'Immacolata,
in Piazza di Spagna

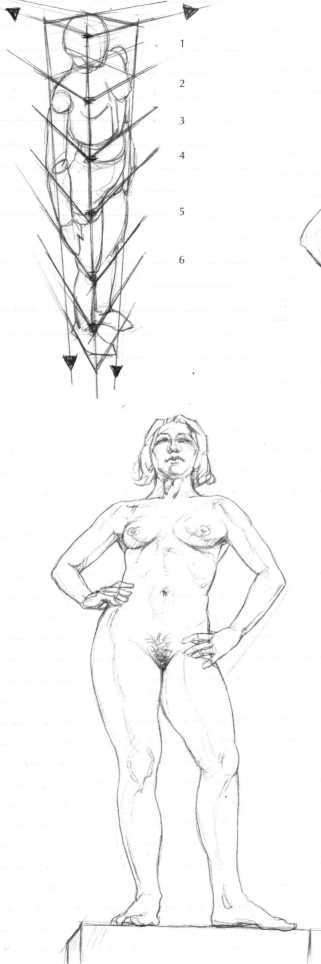

Our view of the human body is typically a foreshortened one, as it is when we look at other animals. This occurs not only when the whole figure is being studied, but also when just a part is being observed (the head, an arm, a foot, etc.). If the model is being portrayed from a somewhat unusual viewpoint (for example, from very close up, from above or from below), or if these viewpoints form part of an imaginative composition, it is a good idea to portray the figure using three-point perspective, or at least construct a simple geometrical reference plan into which the figure can be inserted (as shown on page 49).

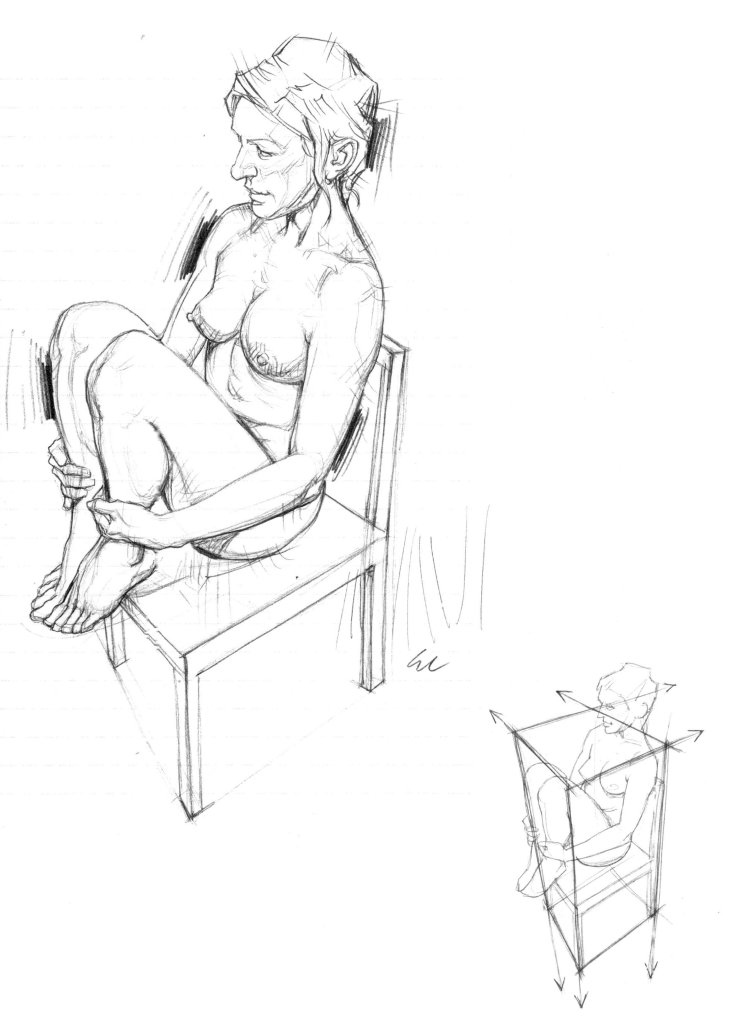

# USING CONSTRUCTION LINES

*On voit tout autrement un objet dont on connait la structure*
[When we know the structure, we see a completely different object]
Paul Valéry

The word 'structure' comes from the Latin verb *struere*, to construct – the way in which the parts of an object come together to form a whole, i.e. the relational arrangement between an object's composite parts. It is very important for an artist to understand a form, be it manmade or organic, in terms of its structural characteristics. This is achieved by seeing the object stripped of its inessential details, and therefore concentrating on it as an arrangement of simpler geometrical forms: cubes, oblongs, cylinders, etc. It can also be helpful to supplement this intuitive investigative framework with a kind of x-ray vision, enabling the artist to visualise the non-visible lines of the object's linear and perspectival structure, as if viewed as a cross-section.

This is partly based on symmetrical relationships and linear directions that are found between an object's parts, and partly on the logical sense they make together in terms of size and fit.

When drawing from life or executing a design drawing, the study is begun by drawing lines freehand to indicate the relationships between the different planes, the subject's main axes and thicknesses. These lines then act as directional guidelines and reference marks when the drawing is developed to the desired degree of precision. The lightly drawn lines may be left visible in order to heighten awareness of the object's structural framework, or they may be gradually overlaid by lines that come later, depending on the particular style of the artist and of the picture.

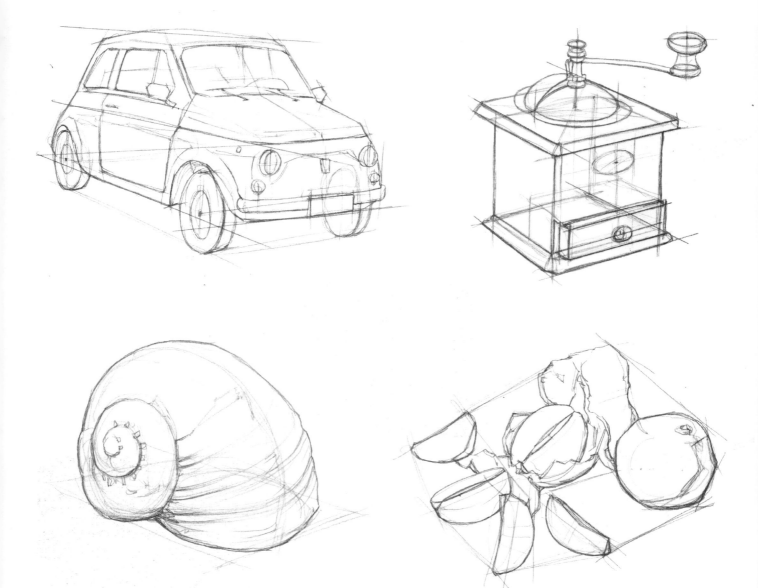

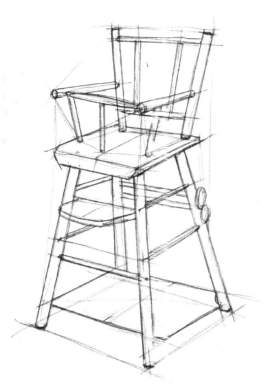
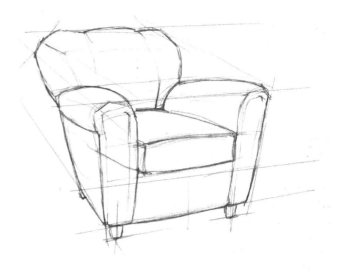
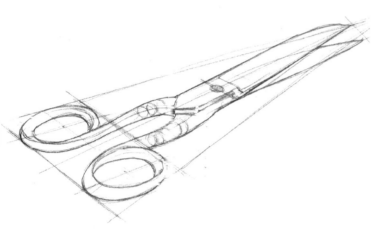
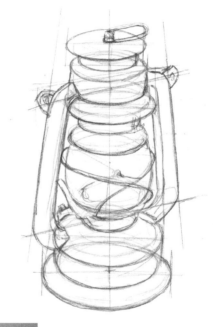
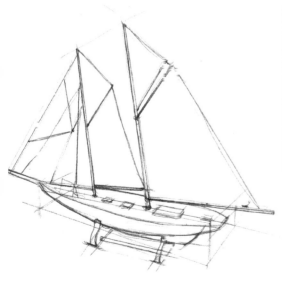

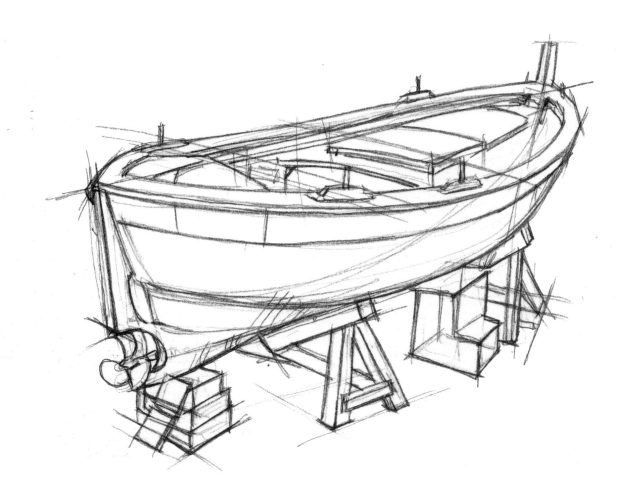

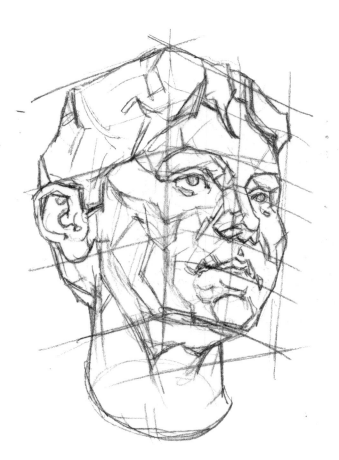

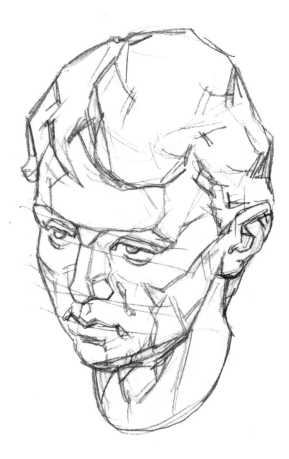

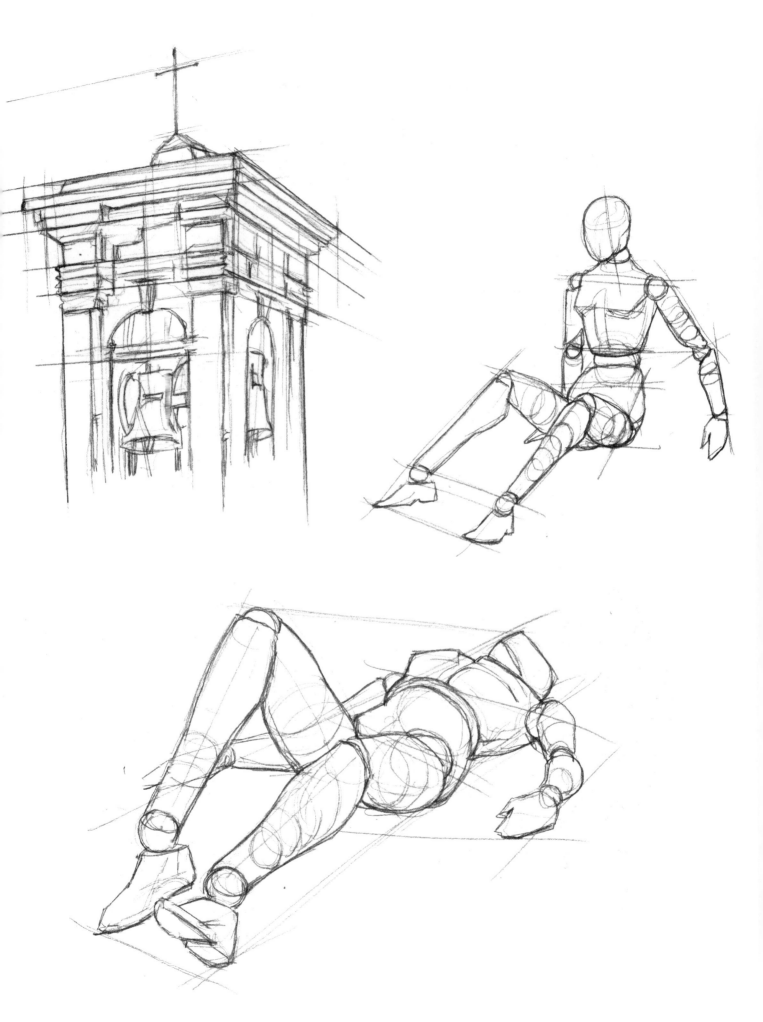

# PROJECTED SHADOWS

Shadow falls in an area not illuminated by direct light. It includes self-shadow, where the object casts a shadow on itself, and projected or carried shadow where the shadow falls on an adjoining object. The light source may be a natural one (the sun, moon or firelight, for example) or an artificial one (a lamp), and there may be a single source or multiple sources.

In a perspective view, light rays emanating from the sun are considered to be parallel to each other, while those coming from an artificial source are considered to be divergent or radiating in every direction. It is the projecting object that defines the shape of the resulting shadow and as such, the object often reveals unusual or unexpected aspects of itself.

The position and the extent of the shadow are determined by the position of the light source (S). If a vertical line is drawn from S to the horizon line, (directly down from the light source), this point (P), which coincides with one of the object's vanishing points, will also locate the vanishing point of the shadow's outlines. Point S can then be used to indicate the angle of incidence of the light rays on the object, while point P indicates the direction of the shadow. If the light source is in front of, or to one side of the observer, S will be located above the horizon line. If the light source is behind the observer, S will be located below the horizon line.

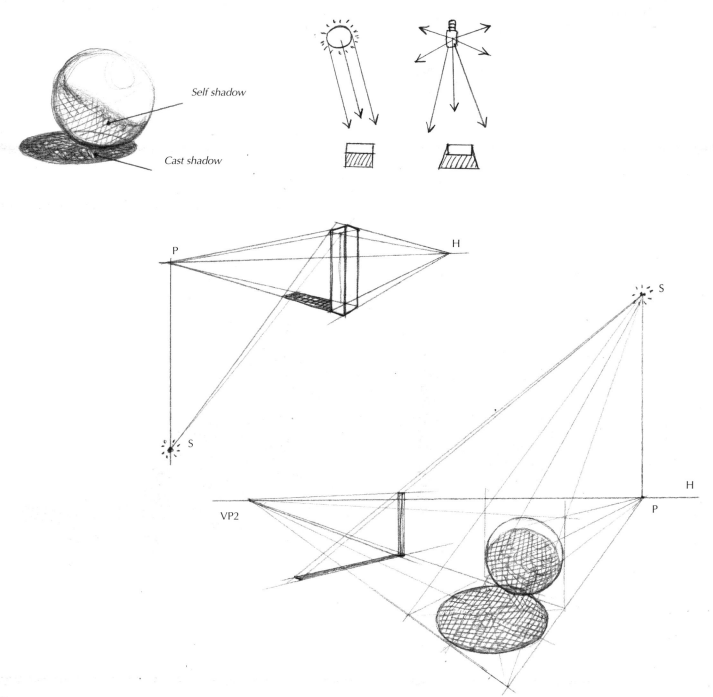

Self shadow

Cast shadow

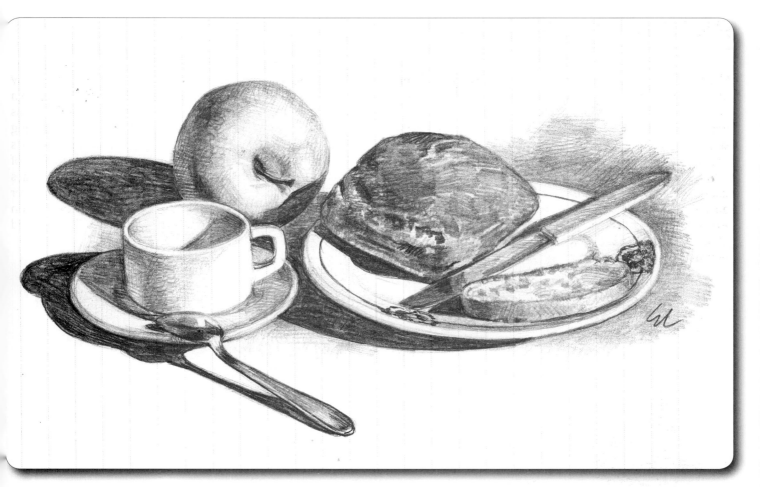

*Breakfast is ready* (2010), pencil on paper, 18 × 23cm (7 × 9in)

*Loving encounter* (2010), pencil on paper, 18 × 23cm (7 × 9in)

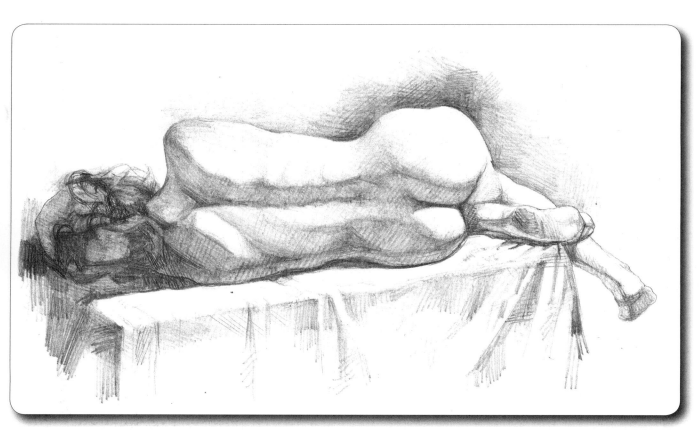

*Corinna* (2010), pencil on card, 18 × 23cm (7 × 9in)

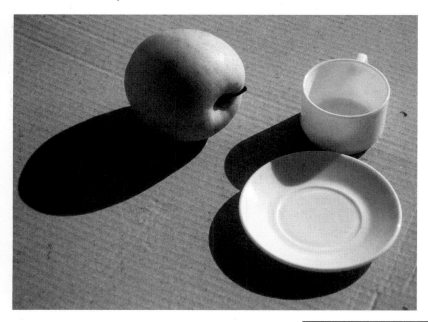

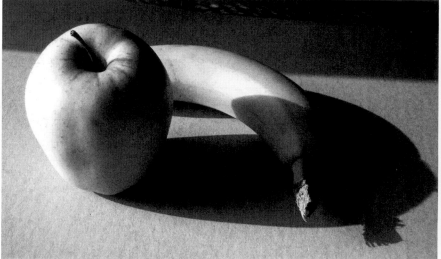

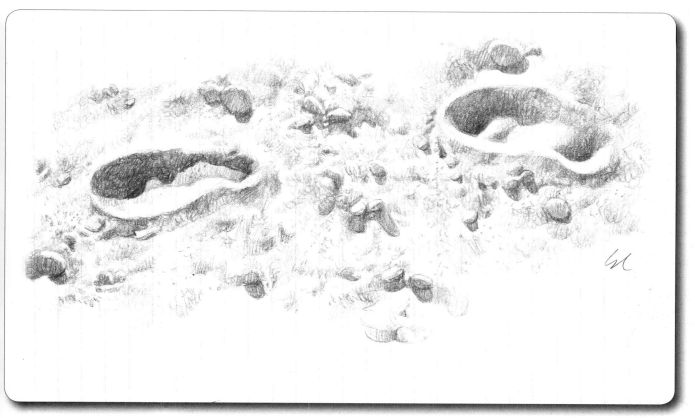

*Footprints of a passer-by, Nice* (2010), pencil on paper, 18 × 23cm (7 × 9in)

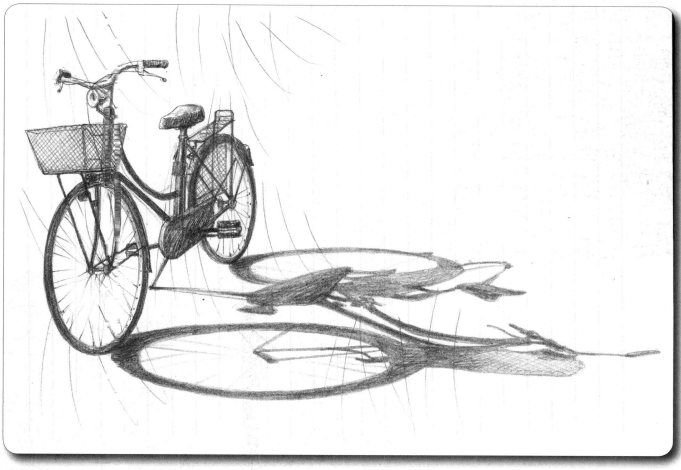

*Shadow at sunset* 2010), pencil on paper, 18 × 23cm (7 × 9in)

# REFLECTIONS

Reflections are an optical phenomenon caused when a light ray hitting a smooth surface bounces off this surface at an equal and opposite angle. The reflecting surface may be horizontal, such as a puddle of water, vertical or inclined at varying angles, as in the case of a mirror. If the surface is horizontal or vertical, the reflected image follows the same perspective projection and has the same vanishing points as the object being reflected. If the surface is inclined, however, the reflection will have its own vanishing points.

The principles of perspective governing the phenomenon of reflection are relatively simple: they state that the reflected image of each point on an object is positioned above, below or to the side of that object at precisely the same distance from the reflecting surface as is the actual point on the object. The principles of linear perspective decide the position, the proportions and the dimensions both of the object itself and of its reflection subject to the axis of reflection and the symmetry of directions of reflection. The reflected image will take on different appearances depending on the condition of the reflecting surface and the distance of the object from this surface. For example:

- If an object is tilted forwards or backwards, this will affect the length and the direction of its reflection.
- If a reflecting surface is irregular or broken, it will produce irregular reflections, or none at all.
- The object's distance from the reflecting surface will determine which portions of it are reflected.
- In some circumstances, a reflected image will reveal aspects of an object that are not visible at horizon level, such as the underside of a table or a bridge.
- If a reflecting surface is not flat, but concave or convex, the reflected image will be markedly deformed in complex ways according to the laws of curvilinear perspective.

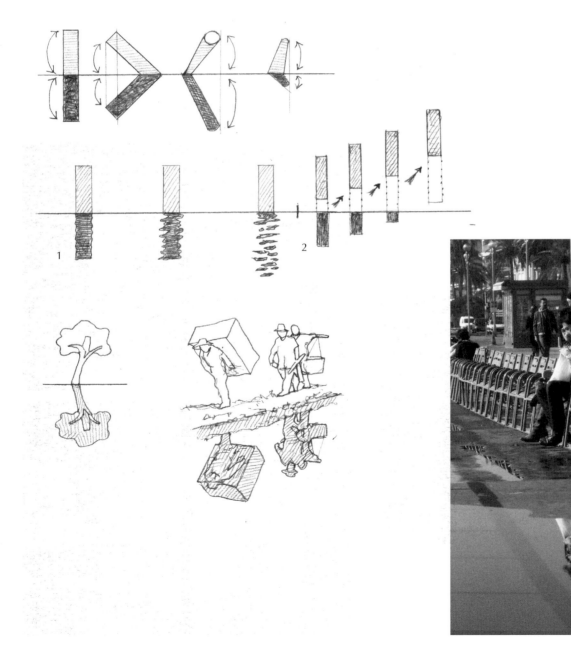

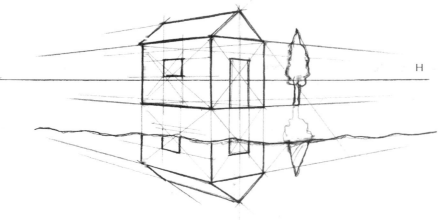

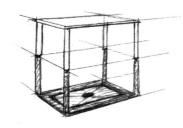

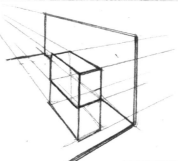

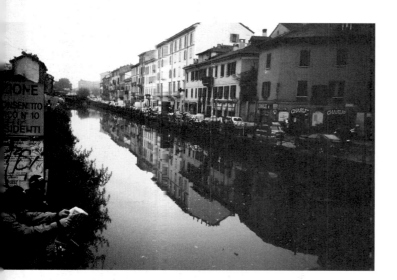

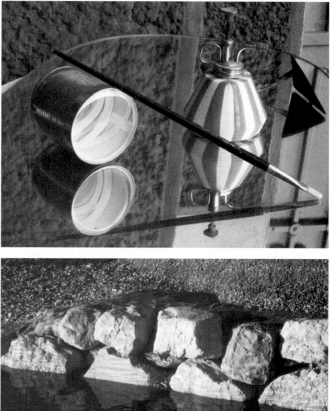

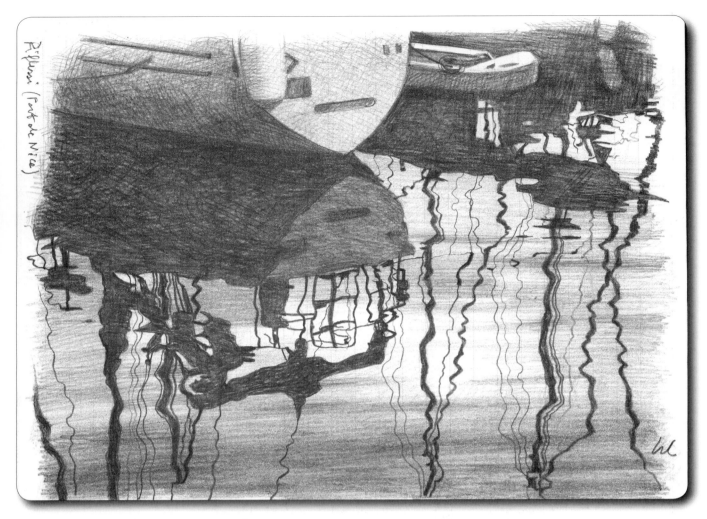

*Reflections, Port of Nice* (2010), pencil on paper, 18 × 23cm (7 × 9in)

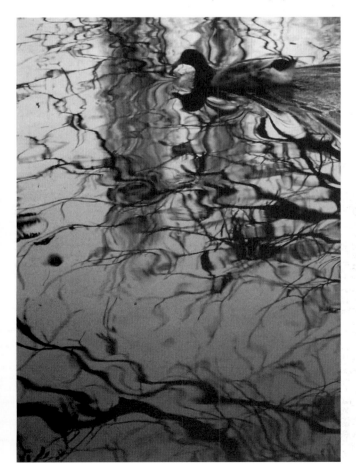

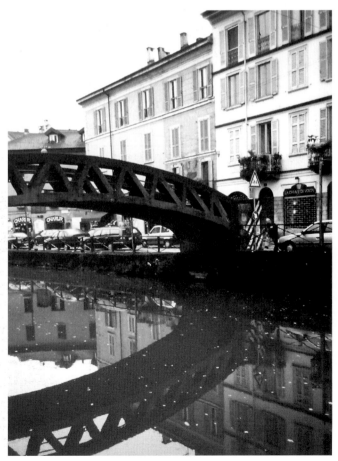

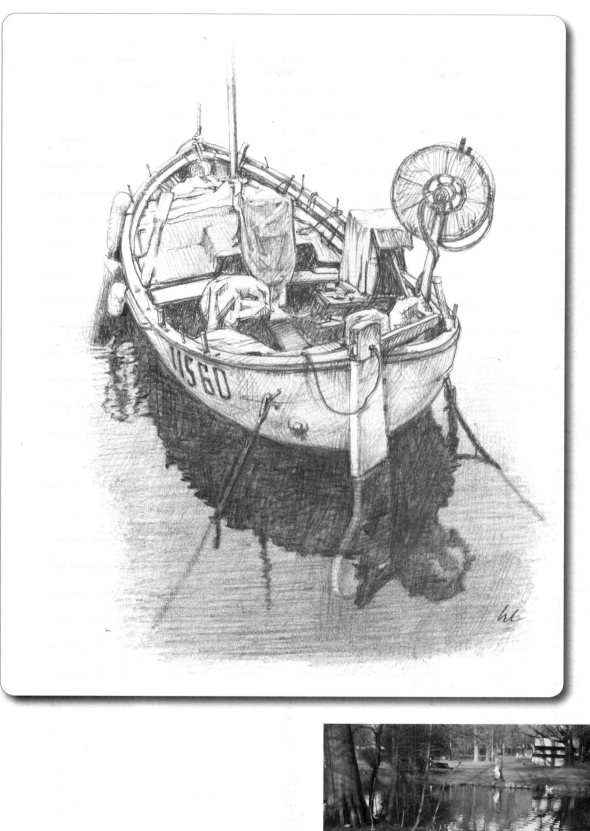

*Jean's boat, Port of Nice* (2010), pencil on paper, 18 × 23cm (7 × 9in)

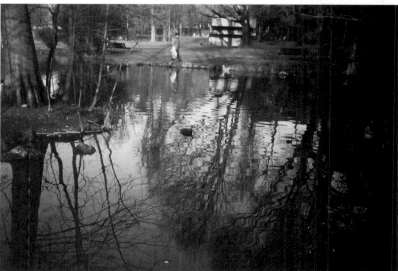

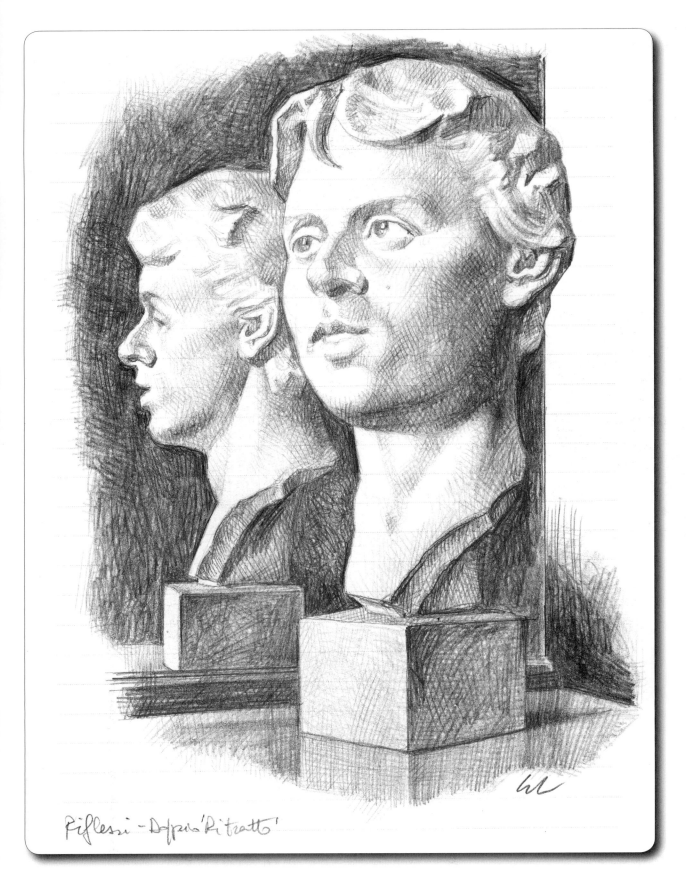

*Riflessi – Dopo 'Ritratto'*

*Reflections: double portrait* (2010), pencil on paper, 18 × 23cm (7 × 9in)

una delle bambole di mia madre.

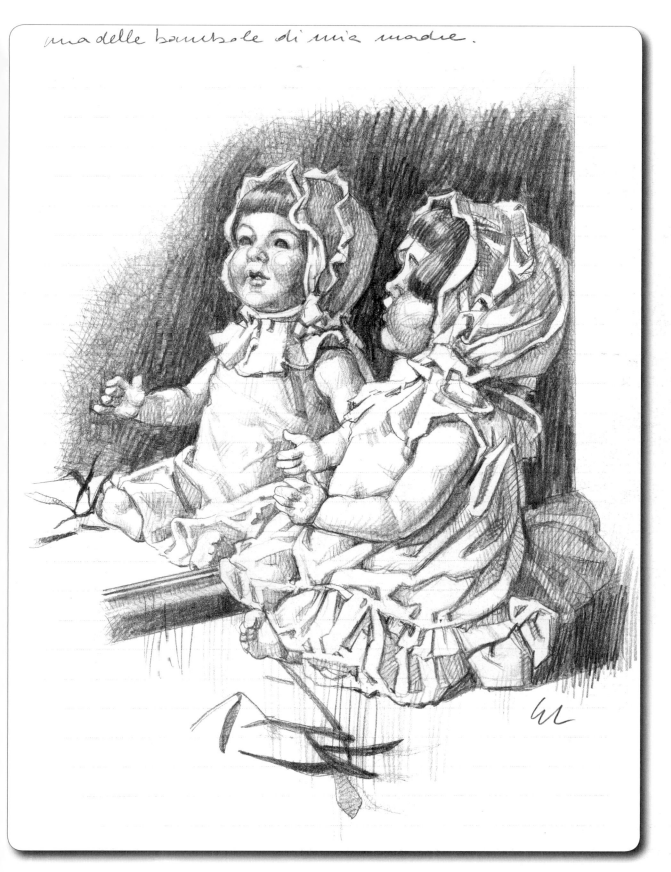

*One of my mother's dolls* (2010), pencil on paper, 18 × 23cm (7 × 9in)

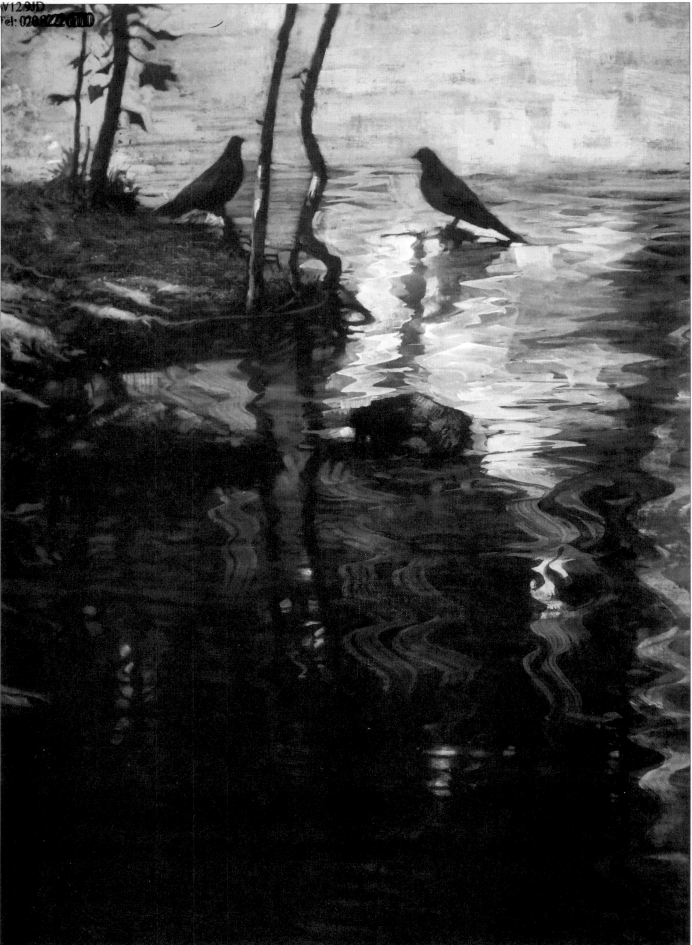

*Pond in the Municipal Gardens, Milan* (1992), black and white gouache on canvas board, 35 × 55cm (13¾ × 21¾in)